· A HISTORY LOVER'S ·
GUIDE TO
CINCINNATI

· A HISTORY LOVER'S ·
GUIDE TO
CINCINNATI

ROBERT SCHRAGE

THE
History
PRESS

Published by The History Press
Charleston, SC
www.historypress.com

Front cover, top: Cincinnati Union Terminal, with clouds. *H. Helvey, Wikimedia Commons*.
Front cover, bottom: Aerial view of downtown Cincinnati, Ohio. *Carol M. Highsmith Archive, Library of Congress*.

First published 2023

Manufactured in the United States

ISBN 9781467152884

Library of Congress Control Number: 2022950032

CONTENTS

Foreword, by Paul A. Tenkotte, PhD 7
Acknowledgements 9
Introduction: The Queen City 11

1. The Queen City: A Historical Perspective 15
2. Along the Waterfront 28
3. The Work of Samuel Hannaford 43
4. Architecture and Historic Structures 65
5. Over-the-Rhine 93
6. Iconic Locations and Museums 105
7. The Neighborhoods of Cincinnati 132
8. Professional Sports in Cincinnati 142
9. Presidents in Cincinnati 151

Notes 177
Selected Bibliography 183
Index 185
About the Author 191

FOREWORD

Cincinnati is an old and charming American city. Nestled between hills, with the Ohio River coursing its way through the valley, the city seems to magically pop into view, especially when approaching it from northern Kentucky. Its skyline is perfection itself. Indeed, architectural historians wishing to study skyscraper architecture—in all its periods and styles—would do well to visit Cincinnati.

As appealing as its skyline and architecture are, however, there is so much more at the sidewalk level of the pedestrian. Cincinnati is home to parks, museums, professional sports, a nationally recognized zoo and symphony, theaters, historic churches and synagogues/temples and vibrant neighborhoods. Along both shores of the Ohio River, Cincinnati and its northern Kentucky neighbors are pedestrian friendly. In addition, a shuttle bus connects the Cincinnati and northern Kentucky riverbanks. Magnificent bridges, like the historic John A. Roebling Suspension Bridge, also span the river. Further, a streetcar ambles between downtown Cincinnati and the city's historic Over-the-Rhine, where shops, restaurants, microbreweries and historic Findlay Market beckon the visitor.

Robert Schrage, in this up-to-date historical guidebook of Cincinnati, is our tour guide to the fascinating city of Cincinnati. His thematic tours guide us through the well-known and little-known places, the historical figures long revered and those historically neglected. He invites us to explore by walking—to see at eye level and to look up at the buildings and view the fine details so often lost by the passersby. Indeed, when we

begin to absorb the finer details, we experience traveling in a whole new dimension. Schrage understands both what engages us and what we should engage with but perhaps never considered.

So, stop your engines. Park your vehicles. Put on your walking shoes. Explore Cincinnati with new eyes. Let Cincinnati embrace you.

Paul A. Tenkotte, PhD

ACKNOWLEDGEMENTS

I would like to thank Kevin T. Kelly, Ethan Schrage, Ann Schrage, Paul Tenkotte, Rick Pender, the staff of the Cincinnati/Hamilton County Public Library, Kenton County Public Library, the Price Hill Historical Society, the Cincinnati History Library and Archives at Cincinnati Museum Center and the Taft Museum of Art.

Introduction

THE QUEEN CITY

S itting on the northern side of the Ohio River across from Kentucky, Cincinnati was settled in 1788 and quickly became one of the nation's most populous cities throughout the nineteenth century. It lies beautifully in a valley with hills nestled on all sides. The Ohio River flows magnificently on its southern side, providing the lifeblood of the community's heart. Cincinnati has been called many things, including the "queen of the West" and the "Paris of America." It was called a queen due to its community pride, expansion westward and even poetry. It all started with an article written by journalist Ed B. Cooke in 1819: "The city is, indeed, justly styled the fair queen of the West: distinguished for order, enterprise, public spirit, and liberality, she stands the wonder of an admiring world." At this time, Cincinnati was the West and symbolized westward expansion. This moniker stuck and was later solidified by the Longfellow poem "Catawba Wine":

> And this Song of the Vine,
> This greeting of mine,
> The winds and the birds shall deliver,
> To the Queen of the West,
> In her garlands dressed,
> On the banks of the Beautiful River.

The city was also styled the "Paris of America," due in part to ambitious architectural projects like Music Hall, Cincinnatian Hotel and Shillito

Department Store. Many of these historic structures still exist. Winston Churchill even called Cincinnati one of the nation's most beautiful cities. He said, "Cincinnati, I thought, was the most beautiful of the inland cities of the Union. From the tower of its unsurpassed hotel, the city spreads far and wide, its pageant of crimson, purple and gold laced by silver streams that are great rivers."

Today, Cincinnati is a vibrant community made up of diverse neighborhoods, a lively downtown, strong arts and culture, professional and collegiate sports and unique restaurants—all the amenities of a large American city. However, what is most important for this guidebook is the history of Cincinnati expanding back to its settlement on the great Ohio River in the late 1700s. This guidebook will provide an opportunity for the reader to explore Cincinnati and its history while traveling its modern streets, with its tall buildings, parks, murals and people going about their daily lives. This book will first explore the history of the Queen City from settlement through immigration and into this century. Cincinnati has a tremendous history related to settlement, including time as an outpost fort, involvement in the canalization of the Ohio and time when majestic steamboats called the community home. Many of the nation's grand steamboats were built right here on the shores of the Ohio River in Cincinnati. Today, the river shore is full of beautiful parks, monuments, stadiums and various cultural and entertainment venues.

This guidebook will also take the reader to Cincinnati's many historic buildings, including those built by the renowned architect Samuel Hannaford. His beautiful structures are, in a way, pieces of art, shaping the landscape of downtown. They take you back to times past while standing on a modern street, reflecting on where the community has been and where it is going. Thriving destinations like Over-the-Rhine and Findlay Market provide glimpses of Cincinnati as it once was and as it is today.

Exploring some of the churches, art and public spaces of Cincinnati will fill any traveler with inspiration and firsthand lessons about the history of the area. Cincinnati is a community full of public murals that depict the city's most famous people and significant history. Interestingly, Cincinnati has a tremendous history of professional sports, including not only the first professional baseball team but also active NFL football, MLS soccer and minor-league hockey teams. The history of college sports in Cincinnati goes back many years. The University of Cincinnati is home to Nippert Stadium. According to the University of Cincinnati's (UC) web page, "UC has used the Nippert site as a playing field since 1901, making it the

second-oldest playing site in the nation for college football behind Penn's Franklin Field (1895)."

The city also has sundry links to American presidents, whose stories can still be seen if you know where to look. Rutherford B. Hayes started his career in Cincinnati, and William Henry Harrison started his education here. The 1876 Republican Convention, held in Cincinnati, launched Hayes to the presidency. William Howard Taft's boyhood home still stands. And Lincoln visited Cincinnati a few times, including while on the way to his first inauguration. Seeing where Lincoln spoke is awe-inspiring.

Exploring Cincinnati is easy and can be done by car or walking. Three interstates run toward downtown: I-75, I-71 and I-471. Downtown has a free streetcar. The bus system, Queen City Metro, provides wide transportation services and routes. In northern Kentucky, the TANK bus system makes drop-offs downtown. The main numbered streets run east–west, and the key named streets run south–north. The named downtown streets, starting in the west, are Central Avenue and Elm, Race, Vine, Walnut, Main, Sycamore and Broadway Streets. Maps can be found all over town, online and through the visitor's bureau. Remember, Cincinnati is also a city of hills. Looking at Cincinnati from across the Ohio River, the hilly nature of the city is clear. Some people call Cincinnati the City of Seven Hills. The hills include Mount Adams, Mount Auburn, Mount Harrison/Price Hill, Walnut Hills, Fairmount, Mount Lookout and Mount Echo. Getting to some of these hills may require transportation aside from walking.

Enjoy traveling the streets of Cincinnati. Whether you are a visitor to Cincinnati, a new resident or an old-timer, this guidebook will help you explore the modern vibrancy and history of the Queen City. As one of the oldest cities in the Midwest, Cincinnati has history in its bones.

THE QUEEN CITY

A HISTORICAL PERSPECTIVE

In exploring Cincinnati and its sights and sounds, it is important to review some major historical components that define the city. This chapter will provide the background necessary to fully appreciate what the reader will see in using this guide. It will explore the early years of settlement, the Underground Railroad, steamboats and the public landing and immigration. Most of the places in this guidebook were greatly influenced by at least one of these fundamental historical components. Whether it is an architectural marvel, a piece of music, a public landmark, a church, a business, a sports complex or a food and beverage place, all can be traced to settlement and growth along the river, as Cincinnati is a northern city with southern and immigrant influences.

It is time to start this journey through the city.

THE EARLY YEARS OF SETTLEMENT

The name Losantiville was conceived by John Filson and was related to the city's proximity to the river that flows into Ohio from Kentucky. Its literal translation is "the city opposite of the mouth of the river." Settled in 1788, Losantiville can be traced to this time by settlers, including Robert Patterson, Mathias Denman, Israel Ludlow and Filson. According to the book *Cincinnati: Then and Now*, on December 28, 1788, "Flatboats carrying eleven families and twenty-four men pulled to shore at an inlet marked by

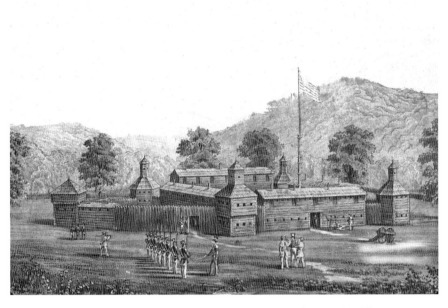

Fort Washington. *From the collection of the Cincinnati and Hamilton County Public Library.*

a sycamore tree....The settlers broke down the boats and used the wood to build the first houses." This would become the spot of Sycamore Street in downtown Cincinnati.

In 1789, Fort Washington was built as a territorial fort. It was located directly across from the Licking River in what is today downtown Cincinnati. It provided protection for settlers and served as a military post. A plaque at the site of the powder magazine can be found on the side of the Western and Southern Garage toward the base of Broadway Street. On top of the garage is the now-inoperable Western and Southern spinning clock, a staple of downtown for many years. The powder magazine's location plaque reads, "The magazine was a five-sided structure of hand-hewn timbers and planking. It was approximately 25 feet deep. Here was stored the ammunition for the expeditions of the Indian wars, which broke the Indian resistance and opened the Northwest territory to peaceful American settlement." The plaque was erected in 1953, and while it is hard to imagine the settlement of the Northwest Territory was "peaceful," that is what the plaque claims. Where was the remainder of the fort? A plaque marks the spot on the Guilford School building at 421 East Fourth Street. Locating it, visitors see the location of a key part of Cincinnati's history.

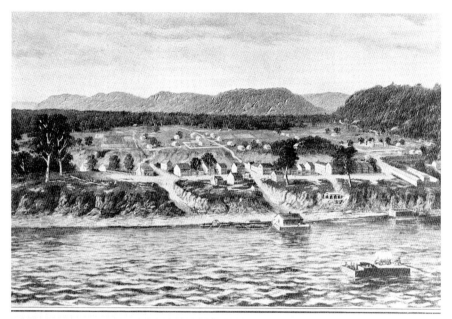

CINCINNATI IN 1802.

Cincinnati in 1802. *From the collection of the Cincinnati and Hamilton County Public Library.*

How did Losantiville become Cincinnati? The governor of the Northwest Territory, General Arthur St. Clair, changed Losantiville to Cincinnati in recognition of the Society of Cincinnati, a fraternity of Revolutionary War officers. The fraternity, in turn, was named after Lucius Quinctius Cincinnatus, a Roman leader. According to the online version of *World History Encyclopedia*, Cincinnatus "responded to a call from the city fathers, left his plow lying in the fields, donned his senatorial toga, and led the Roman army to victory over the invading Aequi, only to return to his small farm 15 days later. For generations, he served as the symbol to Romans young and old of what a loyal citizen ought to aspire." Today, many see him as a symbol of what a politician should be—do your duty and return home to your community to serve locally. He was sort of the anti–career politician.

Cincinnati was chartered as a city by the Ohio General Assembly in 1819, and it boomed. By 1850, it was the sixth-largest city in America and had a population of 115,435. From the time of its charter, Cincinnati doubled in population every ten years.[1] During this time, the public landing was bustling. Before the city's growth moved northward and away from the river, its public landing was made up of warehouses, shops, grocery stores and pork packing businesses. It was not at all beautiful. Cincinnati became

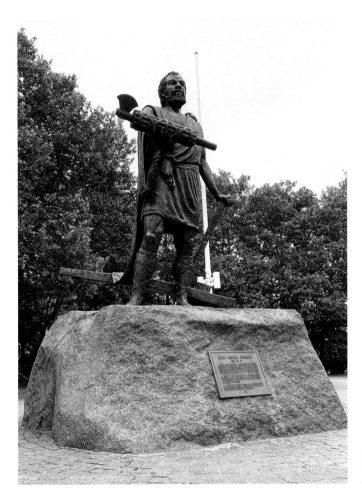

Cincinnatus statue
at Sawyer Point.
Kevin T. Kelly.

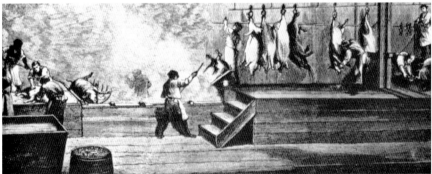

Cincinnati pork production in action. *From the collection of the Cincinnati and Hamilton County Public Library.*

known as "Porkopolis," due to its unpleasant slaughtering processes and pigs roaming the streets. Needless to say, it smelled. In 1855, meatpacking made up approximately 15 percent of the values of goods in Cincinnati. Today, the negative term is a marketing bonanza. Entering Bicentennial Commons Park on the riverfront, one passes through four smokestacks, with flying pigs on top of each. The not-so-glamorous history has led to many themed organizations and events centered on pigs. The Flying Pig Marathon is one such example.

THE UNDERGROUND RAILROAD INFLUENCES CINCINNATI

Cincinnati was a northern city but had a lot of southern influences from business interests. It was also directly across from Kentucky, where slavery was legal. Regardless, the Underground Railroad became an important part of the region's history. Some southern support certainly existed in Cincinnati, but the Underground Railroad became a means for enslaved people to escape from slavery. In fact, the Ohio River became known as "the River Jordan on the path to the promised land."[2] An important individual in Cincinnati's history is Harriet Beecher Stowe, the author of *Uncle Tom's Cabin*, as the book was inspired by her time in the city. This time impacted both her legacy and, of course, her classic antislavery book.

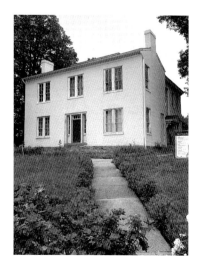

The house she lived in during her time in Cincinnati still stands and is located at 2950 Gilbert Avenue. It was not long after leaving Cincinnati that she wrote the novel, and within a year, she sold three hundred thousand copies. Cincinnati is home to the National Underground Railroad Freedom Center, whose mission, according to the center's website, is "to pursue inclusive freedom by promoting social justice for all, building on the principles of the Underground Railroad." It sits in both a beautiful and fitting location near the Ohio River, the physical barrier that separated free and slave states. Find the Roebling Suspension Bridge, and you will be in front of the center.

Harriet Beecher Stowe house. *Kevin T. Kelly*.

The impact Cincinnati had on the Underground Railroad was significant. According to Wikipedia, "Beginning in the late 1840s, Levi Coffin, a resident of Cincinnati, helped more than three thousand slaves escape from their masters and gain their freedom in Canada." Many enslaved people who were headed to Canada stopped in Cincinnati. In 1850, Cincinnati had the third-largest Black population of any city in the United States.[3]

STEAMBOATS AND THE PUBLIC LANDING

The public landing of Cincinnati is perhaps, historically, the most significant piece of land in the city. Its impact on the city's settlement, growth, economy and culture cannot be overstated. It is a tremendous resource of Cincinnati history. The *Cincinnati Guide*, published in 1943, says that throughout the city's history, "the Ohio River was leading Cincinnati to greatness." However, "business [was] centered at [the] public landing, where steamboats came and went, whistles blew, crowds milled, and the wharf towered high with merchandise." The 1943 guide says it well: "This enormous activity was directly traceable to the Ohio River. Cincinnati's epic rise sprang from its situation on the river and from the changing types of crafts that passed over it."

Before the time of Fort Washington, boats first traveled to the region on the Ohio River. Passenger service between Pittsburgh and Cincinnati began in 1793. It was expensive to haul goods over the mountains from Philadelphia; thus, New Orleans was the significant travel partner for Cincinnati. Other inland communities sent their goods to New Orleans, and Cincinnati was a convenient midway point between Pittsburgh and Louisiana.[4] Of course, many of the early boats were rudimentary flatboats and keelboats. All that changed. Steamboats had the same revolutionary impact the railroads had later in the nineteenth century and airplanes had in the twentieth century.

By the early 1800s, steamboats were plentiful on the Ohio River. Commerce was certainly the predominant reason for this abundance of steamboats, but they also served as people movers. According to the Ohio History Connection's website, Cincinnati was not only a transportation point for the steamboats, but it was also a major hub for their construction. The Ohio History Connection states, "Although most of the earliest steamboats came from Pittsburgh or Wheeling, within a short period of time, Cincinnati had also emerged as a significant part of the industry. Cincinnati shipyards launched twenty-five steamboats between 1811 and

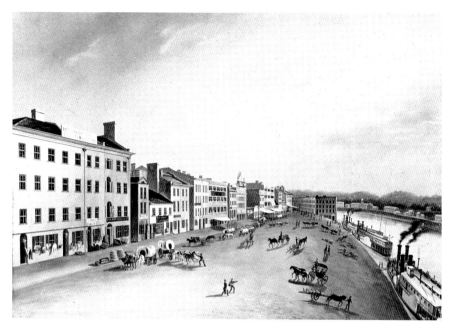

Public landing. *From the collection of the Cincinnati and Hamilton County Public Library.*

1825, and the number only increased after that period. The industry and the transportation system that it developed helped Cincinnati to become one of the most important cities in the West prior to the Civil War." In a March 2021 *S&D Reflector* article, published by the Sons and Daughters of Pioneer Rivermen, "Cincinnati was a center of steamboat building during the 19th century. The first steamer built in the area was the tiny VESTA of 1814, while one of the last constructed in a Cincinnati yard was the elegant and long-lived Queen City of 1897. Boat building apparently peaked in the 1840s and 1850s, when 1,000 men produced about 30 boats a year." Burton Hazen Shipbuilding was directly across from Dayton, Kentucky. The Burton Hazen Shipbuilding operation was located on Hazen Street in Cincinnati, off today's Riverside Drive. The site can be seen while standing on Berry Street in Dayton, Kentucky, looking across the Ohio River at the foot of Hazen Street in Cincinnati. This area was a city called Fulton, and it merged into Cincinnati in 1855. Four shipyards were located in Fulton.

To recognize Cincinnati's significant history related to steamboats, the National Steamboat Monument was constructed at the Public Landing at Sawyer Point. It is a thirty-foot-tall replica of a paddlewheel, with twenty-four metal smokestacks playing music and releasing steam. The red

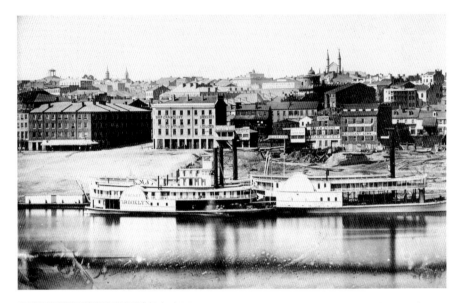

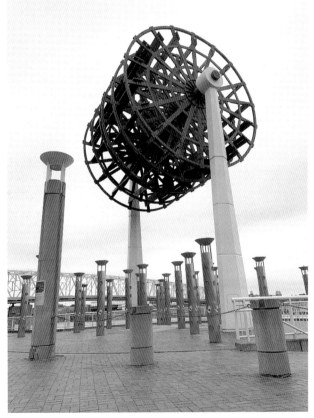

Above: Early steamboats at the Cincinnati public landing. *From the collection of the Cincinnati and Hamilton County Public Library.*

Left: The National Steamboat Monument. *Kevin T. Kelly.*

paddlewheel is a replica of the one on the *American Queen*. Also, a nice way to see Cincinnati from the river is aboard a boat from BB Riverboats, located in Newport, Kentucky. The company's first cruise was in 1980 on the *M/V Betty Blake*, and it has been cruising since. There is always a certain amount of romance and nostalgia when cruising on a riverboat.

In the grand scheme of things, the steamboats had a relatively short heyday. The railroads took the nation by storm. According to the Ohio History Connection's website, "Construction of the Cincinnati, Hamilton, and Dayton Railroad (CH&D) began in 1851. The railroad attracted German and Irish immigrants who were looking for work. After the railroad was completed, these immigrants stayed in the region and found work in factories that began to emerge near the railroad and the Miami and Erie Canal. In its early years, the railroad line had the nickname 'Charge High and Damn Rough Ride.'" After the Civil War, Ohio's growth in railroad mileage grew at an amazing pace. In the 1860s, the source of Cincinnati's strength, "the Ohio River, with its tributaries and canals, seemingly became her weakness as railroads transformed the nation's transportation routes."[5]

IMMIGRATION

In providing a historical perspective of Cincinnati, it is important to explore immigration and its impact on the culture and growth of the community. Understanding this impact helps explain today's city. The first settlers of Cincinnati were mostly protestants of English and Scottish ancestry. In 1830, only 5 percent of the city's population had German roots. Within ten years, the German population reached 30 percent, and it doubled between 1840 and 1850. By the 1850s, the German language was used in four Cincinnati newspapers and in countless schools and churches.[6]

According to Cincinnati: A City of Immigrants' website:

> *Many German immigrants arrived in Cincinnati searching for new opportunities, and some came with funds to buy land. They often had technical skills or could work as tradesmen, such as butchers, bakers, or tailors; however, German Catholic immigrants were often denied work at publicly financed construction jobs and were excluded from joining clubs established by native-born Cincinnatians. German customs clashed with the lifestyle of American-born Protestants who frowned upon the way that German families spent Sundays in theaters, saloons, and various singing*

societies. Catholic loyalty to the pope in Rome seemed to prohibit the notion that these foreigners could ever become proper American citizens. This anxiety grew, resulting in the formation of the "Know-Nothing" Party in the 1850s. A political group of nativists, they were alarmed as immigrants, Catholics, Jews, and blacks streamed into "their city." The panic continued to grow, causing a major riot on Cincinnati streets.

German immigrants settled in the area of Cincinnati called Over-the-Rhine, and no visit to the city is complete without visiting this important historic, residential, cultural and now entertainment district. It is a trip back in time.

An important group of these immigrants were German Jews. Before 1830, Cincinnati's Jewish population numbered approximately 150, and they were mostly English-speaking individuals. By 1860, an additional 8,000 to 10,000 Jews had come from Germany.[7] Rabbi Isaac Wise, the founder of Cincinnati Hebrew Union College, started the Plum Street Temple on the corner of Eighth and Plum Streets, directly across from city hall. Because of Wise, "the city became a center of Jewish thought in America."[8] The temple was completed in 1866, after some delays were caused by the Civil War. According to the temple's web page, "The building reflects the Byzantine-Moorish synagogue architectural style that first emerged in Germany during the nineteenth century. It hearkens to the Golden Age of Spain in Jewish history and reflects Rabbi Wise's optimism that the developing American Jewish experience would be the next Golden Age. All other examples of such architecture in Germany were later destroyed by Hitler, and only one synagogue of a similar style exists in America [in New York]."

Hebrew Union College was founded in 1875 to educate and ordain American rabbis. Today, it can be found on Clifton Avenue near the University of Cincinnati. At the college is one of the oldest museums of Jewish artifacts in the nation. The Skirball Museum is a must-see for those exploring Jewish history. It also features temporary exhibits that "portray the cultural, historical and religious heritage of the Jewish people." Finally, the Holocaust and Humanity Center at Union Terminal strives to ensure "the lessons of the Holocaust inspire action today."

A hidden historic gem can be found at Chestnut and Central Avenues. It is a small plot bounded by impressive walls. The Chestnut Street Cemetery operated from 1821 to 1849. It is the oldest Jewish cemetery west of the Allegheny Mountains. It was closed in 1849 due to the cholera epidemic.

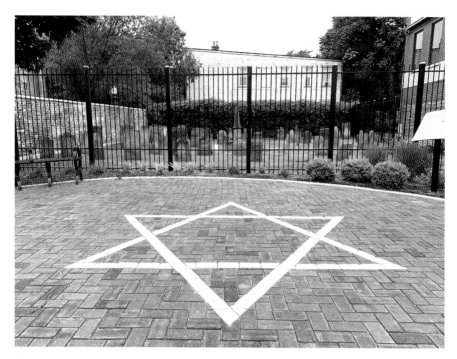

Chestnut Street Cemetery. *Kevin T. Kelly.*

Another unique spot is the abandoned Sherith Israel Temple, located in an alley off the entertainment district in downtown Cincinnati. It is located on Ruth Lyons Lane behind Nicholson's Restaurant across from the Aronoff Center. According to Wikipedia, "It is the oldest existing synagogue building west of the Allegheny Mountains and the fourth oldest building in downtown Cincinnati. It is the seventh oldest synagogue building in the United States. The synagogue was built in 1860 and was an active synagogue until 1882."

In 2021, the community celebrated the Jewish Cincinnati bicentennial, which included a rededication of the Chestnut Cemetery and marked the two hundredth anniversary of Jewish life in the city. Immigrants of Irish descent came to Cincinnati, in part because of the potato famine in 1846. German and Irish immigration greatly raised the Catholic population of the city. In total, the arrival of immigrants helped lead to a quadrupling of the city's population between 1830 and 1850. During this period, the population rose from 26,515 to 115,435. In 1860, the population was 160,000. Thus, it was the nation's six-largest city in population and the largest inland. It was the nation's third-largest industrial center.[9]

Sherith Israel Temple. *Kevin T. Kelly.*

Between 1820 and 1870, the Black population of Cincinnati remained relatively the same and was under 3 percent. Black residents have made significant contributions to the history and culture of Cincinnati; however, this was not done without tremendous struggle. According to Eric Jackson, in an article on the Oxford African American Studies Center's web page titled "African Americans in Cincinnati," "Struggles for racial equality, social justice, and economic opportunities have taken place in the city's streets, homes, churches, schools, governments, and workplaces, and these efforts [have] been woven into every fabric of Cincinnati's rich historical tapestry." He goes on further to state:

> *For most of the city's African American residents the supposed "promised land" of Cincinnati never materialized. Thus, despite Cincinnati being located in a free state, its African American citizens had very limited rights and freedoms. For instance, regardless of the Ohio state constitution prohibiting the system of enslavement in 1802, the passage of a series of legal codes, known as the Black Laws, enacted in 1804 and 1807 respectively, left little doubt about the real views of most of the state's white politicians and residents about the presence of persons of African descent. Furthermore, in 1829, an urban race riot erupted when a gang of whites targeted a group of African Americans for walking down the street.*

All of these immigrant groups have greatly influenced Cincinnati. It has not been easy, and strife has certainly been a legacy of Cincinnati's diverse population. Strife between Protestants and Catholics; Black residents and white residents; and individuals on both sides of the slavery question define the history of Cincinnati. All of them endured great hardship, discrimination and rough living conditions. In the late 1800s, Cincinnati was the most densely populated city of any in America. All of these population groups have played a role in Cincinnati's history and thus made the community what it is today. Their struggles enhance our appreciation for both their resiliency and contributions to Cincinnati. In exploring Cincinnati using this guide, immerse yourself in the legacy of the immigrants who called the city home and created the culture that citizens and visitors connect with today.

ALONG THE WATERFRONT

Enjoying the waterfront of Cincinnati is a simple thing to do. It is made up of a series of beautiful parks, all of which contain recreational activities and historical sites. It is a busy area, stretching from Paycor Stadium in the west to Theodore Berry International Friendship Park on the east side of downtown. To enjoy a stroll through the sites of the waterfront, this guide will work from west to east.

Before starting through the park, take a look at the Cincinnati Black Music Walk of Fame, located at the Andrew J. Brady Music Center, next to Paycor Stadium. It celebrates and recognizes the music of individuals and groups from Hamilton County and southeastern Ohio.

In the summer, one of the first things to notice of the waterfront parks is the beautiful landscaping. Sitting in swings or lounging on the vast lawn, it is easy to get mesmerized by the flow of the river and to reminisce on days gone by in the historic Queen City.

JOHN G. AND PHYLLIS W. SMALE RIVERFRONT PARK

This riverfront park starts at Paycor Stadium and is named after John Gray Smale, who was the CEO of Cincinnati-based Procter & Gamble from 1981 to 1990, and his wife, Phyllis. It contains play areas, riverfront swings and other amenities. Follow the paths and lawns to explore on foot or enjoy a peaceful bike ride through the various sidewalks.

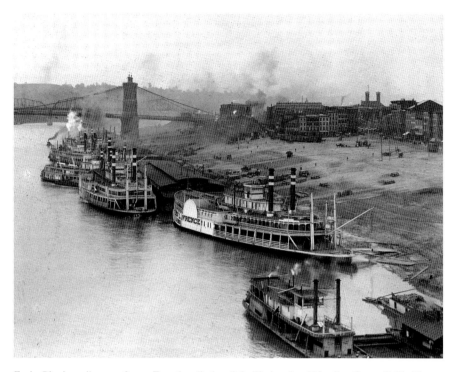

Early Cincinnati's waterfront. *From the collection of the Cincinnati and Hamilton County Public Library.*

1 WEST VINE STREET

This vantage point has a perfect view of the Roebling Suspension Bridge. A stone column stands out on the lawn and contains a sign. The column sign reads in part:

> *This stone column is from a building that stood at this location in the 1840s. The building was at the corner of Water Street and Vine Street. A series of different businesses occupied the site over the years. The Simmons Milling Company was in this building in 1904. Water Street was the southernmost street in early Cincinnati, located where the park's Water Street Esplanade was built. The Esplanade, linking the Vine Street Water Garden to the area under the Roebling Bridge, follows the same path as Water Street did. The stone was uncovered when the park's Great Lawn was being built, and it is a reminder of the city's early development and rapid growth on the banks of the Ohio River.*

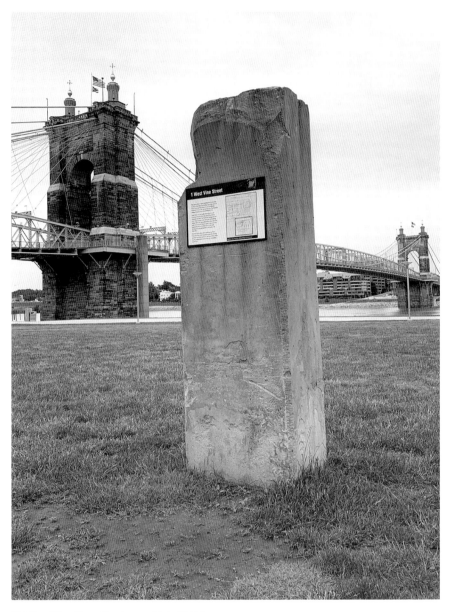

"1 West Vine Street" column. *Kevin T. Kelly.*

FOUNDATION WALLS

Near the Roebling Suspension Bridge are a series of foundation walls that were built circa the 1840s. A 1904 Sanborn map shows one of the earliest Kroger Production facilities at this site. The city bought this site after Kroger left it in 1960. It then became a parking lot for Riverfront Stadium, the home of the Cincinnati Reds from 1970 to 2002.

What occupied the site originally is a more extensive question. In a website article (June 5, 2015) by Anne Senefeld, she discusses in great detail the history of the foundation walls:

> *Using deed and lease information, I could begin to determine exactly who lived in the lots in questions [sic]. I also determined, using present-day maps with the bridge in place, that the address of the now-exposed foundations are most likely the western wall of 59 Water Street and the complete basement of 61 Water Street (pre-1896 address). In 1846, Issac C. Hull had his carriage making business at 59 Water Street, and A.W & J. Patterson were rectifiers, people who blended raw whiskey to a certain taste, working*

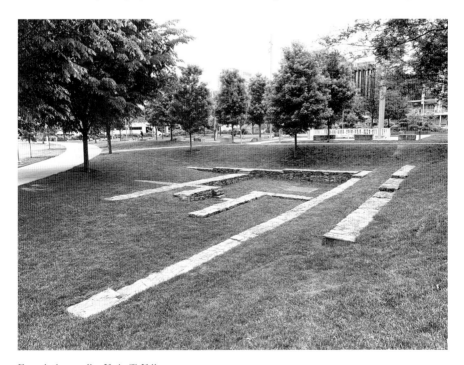

Foundation walls. *Kevin T. Kelly.*

at 61 Water Street. However, in 1848–49, Patterson was running a produce houses [sic] and the next year, it was a feed store. In 1850, the first floor of 61 Water Street became a coffee house, run by Matthew Keegan, called the Robert Emmet House until 1863. The 1853–1885 directories show that at 59 Water Street, there was a grocer named John Holon. In 1857, Thomas Emery, who had arrived in Cincinnati in the mid-1840s, moved his candle and lard oil business from Water Street, between Walnut and Main Streets, to the southeast corner of Water and Vine Streets. It appears he built new structures when the business moved; however, Thomas died in an accident at this location on December 30, 1857. Thomas's sons, Thomas Jr. and John J. Emery, continued the business, along with the many real estate holdings the family began to acquire. The Emery family began building many apartment buildings, hotels, theaters and landmarks associated with Cincinnati, including Carew Tower. The candle and oil business continued at Water and Vine Streets until 1886, when it was moved to Ivorydale.

ROEBLING SUSPENSION BRIDGE

Perhaps the most significant historical site in the region is the Roebling Suspension Bridge. It opened on December 1, 1866, and at the time, it was the longest suspension bridge in the world, spanning 1,057 feet between the towers. According to the *Northern Kentucky Encyclopedia*, construction on the bridge started in 1856; however, the economic panic of 1857 and other factors caused construction to cease. It did not begin again until around the middle of the Civil War. The towers were completed in 1865, and on December 1, 1865, pedestrians walked the bridge for the first time. On January 1, 1867, the bridge was open to traffic (horses and buggies).

John Roebling was born in 1806 and died in 1869, a few years after finishing the suspension bridge. Many people call the Cincinnati bridge a prototype to the famed Brooklyn Bridge, which Roebling also designed and built. Some locals call it the singing bridge, as cars hum over the grates on the deck. Roebling died as the result of an accident that occurred during the construction of the Brooklyn Bridge. When walking across the Roebling Suspension Bridge into Kentucky, a statue of Roebling can be found on the east side of the structure in Covington, Kentucky. The Cincinnati and Covington Bridge, as it was formally known, was renamed John A. Roebling Bridge in his honor. It was designated a National Historical Landmark in 1975.

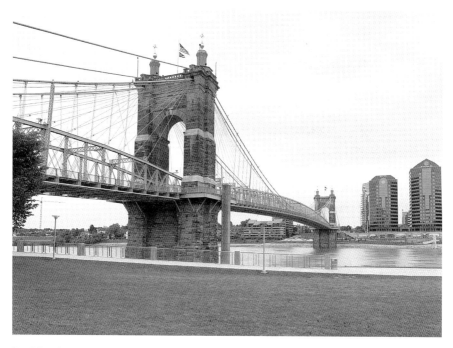

Roebling Suspension Bridge. *Kevin T. Kelly.*

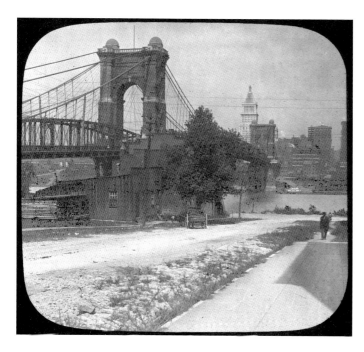

Roebling Suspension Bridge from Covington, Kentucky. *From the collection of the Cincinnati and Hamilton County Public Library.*

CAROL ANN'S CAROUSEL

Located at 8 East Mehring Way, this carousel includes historical panels that depict various key elements of Cincinnati history. The City of Cincinnati announced:

> *Come and take a ride on one of 44 whimsical Cincinnati-centric characters that make up Carol Ann's Carousel. The carousel is an amazing work of art featuring original artwork by Jonathan Queen, with panels depicting animal characters playing in one of the numerous Cincinnati parks. Additional panels celebrate the many historic landmarks of Cincinnati. The carousel is housed inside a glass building so it can operate year-round. It sits just west of the foot of the Roebling Bridge on the Cincinnati side. The carousel—a gift from the Carol Ann and Ralph V. Haile Jr. Foundation—was built by Carousel Works in Mansfield, Ohio, the world's largest manufacturer of hand-carved wooden carousels.*

THE BLACK BRIGADE

The Black Brigade is an important part of Cincinnati history. The Black Brigade Monument is located in the Smale Park's east tree grove and was the first piece of public art in the park. "The monument's concept called for it to be built into the earth, much like the original Black Brigade fortifications. It consists of bronze statues and plaques, interpretive signs, and carved stones, which includes the names of all 718 members of the brigade."[10]

The Black Brigade was a military unit of Black Americans during the Civil War. It was organized in 1862. "The members of the Cincinnati 'Black Brigade' were among the first Black Americans to be employed in the military defense of the Union. The fortifications—including forts, miles of military roads, miles of rifle pits, magazines and hundreds of acres of cleared forests—at the border of northern Kentucky thwarted the major threat to Cincinnati during the Civil War."[11] At the time, race relations in Cincinnati were not good; outright hostility existed from white residents, Black residents could not vote and Black residents had virtually no rights or freedoms. Despite this, the Black Brigade stepped up for their country. A historical marker, in Bicentennial Commons Park (just down the waterfront) describes the Brigade: "Judge William Martin Dickson, who favored enlisting black soldiers in the Union Army, assumed command of the brigade, composed of

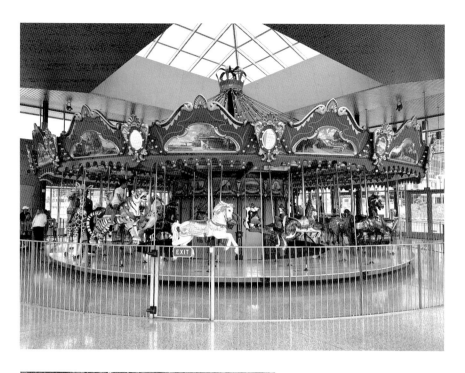

Above: Carol Ann's Carousel. *Kevin T. Kelly.*

Left: Black Brigade monument. *Kevin T. Kelly.*

1,000 African American volunteers determined to fight to end slavery. From September 2-20, they cleared forests and built military roads, rifle pits, and fortifications. Receiving deserved praise for their labor, the unit disbanded when the Confederate forces no longer imperiled the city."

However, it is at the monument where the more complete story is told. It contains a series of well-done sculptured plaques and statues. They tell emotional stories about how "Mothers and Children Anxiously Awaited Return of Their Loved Ones" after Black men were taken from their homes. They awaited their fates on the banks of the Ohio River after being mustered into service to protect the city from a siege. It also tells the story about how they returned home in glory. Lying in a peaceful setting among the trees, this monument stands out as a must-see with an inspirational story of local American heroes.

MARIAN SPENCER STATUE

Installed in 2021, the Marian Spencer statue was the first installed in Cincinnati for a named woman. Spencer was a Cincinnati legend, civil rights activist and politician. Spencer, the granddaughter of a former enslaved person, was the first Black woman to be elected to Cincinnati City Council. Born in 1920, she became the first female president of the Cincinnati chapter of the NAACP and served on the University of Cincinnati's board of trustees. She fought to end segregation in schools and, very famously, the whites-only Coney Island Pool. In 1952, after she and her sons were denied entry to the pool because they were Black, she filed a lawsuit with the NAACP and won. Segregation at the Coney Island Pool ended. Spencer died on July 9, 2019.

The unique statue depicts Spencer with two children holding hands and her left hand free. Visitors can grasp her hand, as well as one of the children's, to create a full circle. Her love of children and fight for unity is symbolized by this simple act of holding hands.

THE PUBLIC LANDING AND SAWYER POINT/YEATMAN'S COVE

In 1811, Robert Fulton brought his steamboat the *New Orleans* through Cincinnati. This was the beginning of the steamboat era in Cincinnati. When walking from Smale Park toward Sawyer Point and Yeatman's Cove Park

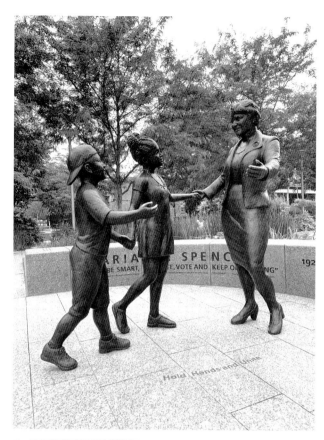

Left: Marian Spencer statue. *Kevin T. Kelly.*

Below: *Delta Queen* at the Cincinnati riverfront, 1987. *Courtesy of the Kenton County Public Library.*

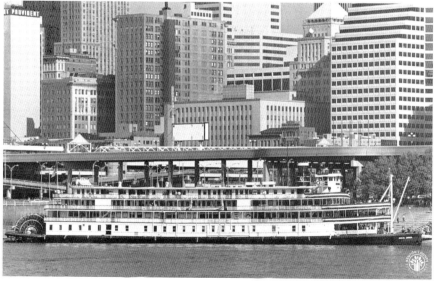

near Great American Ballpark, one comes upon the National Steamboat Monument (described in the introduction of this book). This monument is a reminder of the steamboat heritage of Cincinnati, and to this day, an occasional tall stack will appear at the public landing directly behind the monument. While walking toward Sawyer Point, notice the Steamboat Hall of Fame signs on the pillars. One reads, "This series of 30 plaques comprise a Hall of Fame for some of the most notable steamboats that operated on the inland waterways during the steamboat age in America." It is estimated as many as twenty-five to thirty steamboats per day docked in this area at the peak of the steamboat era.

It is at this public landing that the famed *Delta Queen* made its last appearance in Cincinnati. On October 21, 2008, the *Delta Queen* left Cincinnati for the last time. Around three hundred people attended the goodbye, including this author. It was a beautiful day, and from the top deck, Congressman Steve Chabot, Cincinnati's mayor Mark Mallory and a couple of representatives of the Greene family spoke. The mayor gave the captain a key to the city. Passengers on board tied streamers to the boat's side. The sun was shining from the west, as the day was a couple hours from darkness. As the *Delta Queen* slowly made its way down the river, a band played "When the Saints Go Marching In" and other classics. After it passed under the suspension bridge, it was gone forever.

THE WHO CONCERT TRAGEDY

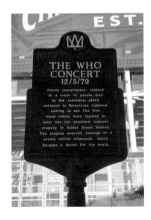

Who concert tragedy historical marker. *Kevin T. Kelly.*

Before heading farther toward Sawyer Point, a small detour will take you to the location of a tragic piece of Cincinnati history. On the right are steps that lead to the plaza level of both the Great American Ballpark and Cincinnati's riverfront arena. At the top of the steps, turn left and proceed around the arena to the main entrance. Standing between gate E of Great American Ballpark and the arena doors is the site of The Who's concert tragedy. It is marked by a historical marker. On December 3, 1979, eleven concertgoers were crushed to death while waiting to see the rock band The Who. The owners of the arena had, for many years, allowed festival seating, and this

author personally experienced the pushing and packing in of concertgoers at other concerts. Finally, after this tragedy, laws were changed, and festival seating in Cincinnati was banned.

Following this stop, return down the steps and resume heading toward Sawyer Point.

Sawyer Point consists of two unique areas: Yeatman's Cove and Bicentennial Commons.

Yeatman's Cove is a park perfectly located for observing river traffic, and it has been home to many entertainment events over the years. The Tall Stacks Festival brought many riverboats to these shores. The most notable feature at Yeatman's Cove is the Serpentine Wall. As a nearby plaque states, Yeatman's Cove marks the site of Cincinnati's beginning. The plaque describes the importance of this spot, and it can be found just before you reach the Purple People Bridge.

THE SERPENTINE WALL

The Serpentine Wall is located at Yeatman's Cove and is, from a practical standpoint, a floodwall. However, its serpentine shape provides a unique vantage point for visitors to see the river from different directions. Completed in 1976, during the nation's bicentennial celebration, the wall descends with steps to the water's edge. Yeatman's Cove Park is located at the site of the city's first tavern, which was established by Griffon Yeatman in 1793. It was popular with men who worked on the river.[12]

BICENTENNIAL COMMONS

After walking under the Purple People Bridge and its beautiful arches, you can find the Cincinnatus statue (described in chapter 1). Near the Cincinnatus statue are a series of historical markers on topics ranging from the Irish in Cincinnati, Cincinnati's German heritage, the *Sultana* and the Black Brigade of Cincinnati.

The Purple People Bridge has connected Newport, Kentucky, and Cincinnati, Ohio, since 1872. It is owned and operated by the Newport Southbank Bridge Company. This former L&N bridge became a pedestrian walkway in 2006. On it is a line marking where Kentucky ends and Ohio begins. For a long time, Kentucky claimed the entire Ohio River

was located in the Bluegrass State. In 1980, the supreme court settled the longtime dispute by ruling the boundary is located at the 1792 low-water mark. When visiting the bridge, it is easy to see the marked boundary and stand in both Ohio and Kentucky at the same time. It is also a great spot for photographs of Cincinnati.

The Bicentennial Commons at Sawyer Point was dedicated on June 4, 1988, in celebration of the city's bicentennial celebration. Charles Sawyer, a Cincinnati philanthropist, gave money to buy the land, supported by other city and county funding. The twenty-two-acre commons houses a large lawn with the P&G Performance Pavilion. The actual north entrance to Bicentennial Commons, called Cincinnati Gateway, is very unique. There is an inexpensive parking lot just in front of this entrance off East Pete Rose Way at Eggleston Avenue. The entrance includes at least eighteen references to Cincinnati's past, including the flood column, golden ark, tall stacks, canal lock, Indian masks, serpent steps, Cincinnati arch, Porkopolis, fish heads and the popular flying pig columns. A sign helps identify the references. It is a lot of fun to find them all while exploring this entrance. Most famous are the columns with flying pigs on top, but just as interesting is the large flood column.

The worst flood in Cincinnati history occurred in 1937, and it is legendary in the minds of Cincinnatians. On January 26, 1937, the river crested at almost 80.0 feet. This 80.0-foot mark appears on the flood column. Below it is the year, 1884, which is when the second-worst flood in Cincinnati history occurred. The river reached 71.1 feet that year. Well above all the marks, toward the top of the column, is the humorous question mark. Will it ever get higher than it was in 1937?

The Ohio River is the largest tributary of the Mississippi River by volume. It runs 981 miles from Pittsburgh to Cairo, Illinois. The river serves as the northern borders of West Virginia and Kentucky and the southern borders of Ohio, Indiana and Illinois. It is the oldest river on the North American continent. The river flows roughly southwest and then west-northwest until it reaches Cincinnati. It then bends to a west-southwest course.

A short walk from the gateway and east of the P&G Pavilion are remnants of Cincinnati's waterworks system. A nearby plaque reads:

> On June 25, 1839, Greater Cincinnati Water Works became the first publicly owned water system in Ohio, when the city purchased a privately owned water company in operation since 1821. This purchase required approval of the voters of Cincinnati and authorization by the Ohio State

Water works remnants in Bicentennial Commons. *Kevin T. Kelly.*

> *Legislature. The waterworks, with two steam pumps at this site, three and a half miles of iron pipe, and 19 miles of wooden pipe, provided one million gallons of water per day. Front Street Pumping Station (ruins at this site) replaced earlier facilities and operated from 1865 to 1907.*

Bicentennial Commons at Sawyer Point features numerous other sites for recreational activities, including pickle ball courts, skating rinks and playgrounds.

THEODORE M. BERRY INTERNATIONAL FRIENDSHIP PARK

The last riverfront park to be developed in the journey from Paycor Stadium was completed in 2003. The Theodore Berry International Freedom Park is named for Cincinnati's first Black mayor. There is a free parking lot at Freedom Park, just off Riverside Drive. Berry was born in Maysville, Kentucky, in poverty and gained tremendous success as a civil rights leader. "He graduated from Woodward High School in 1924 and served as class

valedictorian, the first African American to hold that honor in Cincinnati. In his senior year, he won an essay contest with an entry submitted under the pseudonym Thomas Playfair after an all-white panel had rejected his initial entry. Berry worked at steel mills in Newport, Kentucky, to pay tuition at the University of Cincinnati and then at its law school."[13] Berry served in the administration of Lyndon Johnson and was elected mayor in 1972. He died in 2000 at the age of ninety-four.

The City of Cincinnati's web page says, "Two intertwining walkways guide park visitors through gardens of the continents in a perpetual celebration of international peace and friendship. The park features spectacular and award-winning displays of sculpture and flora representing the five continents and has a riverside bike trail and walking paths." Like all the riverfront parks explored in this guide, Berry Park's landscaping is spectacular.

The art of Berry Park includes *Castle of Air*, *Seven Vessels Ascending and Descending* and the *Crystalline Tower*. The tower marks the eastern end of this journey through the waterfront parks.

CONCLUSION

As discussed earlier, Cincinnati grew northward from the river, but its birth was on the waterfront. Today, the waterfront parks are beautiful reminders of the past and provide excellent opportunities to enjoy the Ohio River. The waterfront provides both historical context and modern amenities for enjoyment. The remainder of this guide will explore the many sites that are evidence of Cincinnati's northward growth. First up is architecture. Of course, most of the city's very early structures are long gone. However, when walking, biking or driving around Cincinnati today, the architecture certainly stands out. This guide will break the topic down into several chapters. The first stop will be the work of famed Cincinnati architect Samuel Hannaford.

3

THE WORK OF SAMUEL HANNAFORD

SAMUEL HANNAFORD

Samuel Hannaford has been called the "man who built Cincinnati." In and around Cincinnati, there are many beautiful nineteenth-century buildings that were designed by this one man and his firm. As a local architect, he designed more than three hundred buildings between the 1850s and his retirement. He died in 1911.[14]

Hannaford was born in England on April 10, 1835, and immigrated to Cincinnati with his family when he was nine years old. He studied at Farmer's College, and according to an article written by Tim Burke:

> Young Samuel, it seemed, was destined to follow in his father's footsteps, with an education focused on farming. However, at the age of 17, Hannaford left home when he clashed with his father over religion, inadvertently setting him on the trajectory to become an architect. Throughout the rest of Hannaford's life, religion was a major influence. Over the course of his career, he worked on more than a dozen churches and chapels across the greater Cincinnati area, a variety of Catholic, Presbyterian, Methodist and Episcopalian churches, though he was devoted member of the Methodist-Episcopalian denomination.[15]

Following a successful apprenticeship with the important architect John Hamilton, Hannaford started his own firm. He was not overly successful, so he then joined the firm of William Tinsley and Edwin Anderson from 1858

to 1870 and Edwin Proctor from 1874 to 1876. From these firms, which included European trained architects, Hannaford was greatly influenced. This European influence can be seen in many of his buildings. Hannaford himself traveled Europe extensively, thus expanding on his vision and talents. For example, according to Burke: "In 1869, Hannaford traveled home to England. In addition to visiting family, he toured London, where he found the gothic architecture of Westminster Abby 'extremely interesting,' calling it 'one of the few places that have come fully up to my expectations,' before moving on to Belgium. During visits to Brussels and Antwerp, he singled out Brussel's gothic town hall built in the 1440s as 'one of the most notable buildings of Belgium' and 'one of its kind in Europe.'"

In 1886, Hannaford, with his newly educated sons Harvey and Charles, formed Samuel Hannaford and Sons Architectural Firm. This firm went on to design many of the important buildings in Cincinnati that are discussed in this chapter. According to the *Encyclopedia of Northern Kentucky*, Hannaford "designed structures covering a broad range of styles that included, among others, Renaissance Revival, Queen Anne, Victorian Eclectic, Romanesque and Beaux. The company designed hospitals, factories, churches, schools, courthouses, waterworks buildings, hotels and family homes." Hannaford also had a tremendous impact on northern Kentucky, designing many important buildings, some of which can be seen today.

Hannaford was married three times and had eleven children. Two of his wives died young. Upon his death in 1911, he was buried in Spring Grove Cemetery. His firm operated until 1964 under the family name. An ArtWorks mural honoring Hannaford can be seen on the side of a building at 1308 Race Street. It is located a block away from perhaps Hannaford's greatest achievement: Music Hall. The mural features three of Hannaford's works, including Music Hall, Cincinnati City Hall and the Elsinore Arch. It also includes a portrait of the man himself.

Samuel Hannaford. *Public domain.*

Samuel Hannaford is the region's most creative and important architect from the nineteenth century. The best way to fully understand and appreciate his influence is to visit some of his works.

THE WORK OF SAMUEL HANNAFORD

This guide takes you to a fraction of the three hundred buildings Samuel Hannaford designed. A good number have been demolished, but many more have survived and can be seen throughout the region. This section will provide a sampling of his portfolio, including some of his most iconic works. There is no better place to start than Music Hall.

Music Hall

Located at 1241 Elm Street, Music Hall is Hannaford's grand masterpiece and has been called the "jewel in the Queen City's crown."[16] Built in 1878, this piece of Victorian-Gothic architecture today houses the second-oldest opera company in the United States, the nation's sixth-oldest symphony, the May Festival (a choral festival that is the longest-running in the western hemisphere), Cincinnati Pops and the Cincinnati Ballet. When looking at Music Hall from Washington Park, it appears to be three separate buildings joined together. Music Hall replaced Sangerhalle (Exposition Hall), which was built for May Festival Choral Concerts. The wings were added for use as exposition halls and hosted some historic events, including the 1880 Democratic National Convention and the 1888 centennial celebration. In 2016–17, Music Hall underwent a major restoration and reopened in 2017. It was designated a National Historic Landmark in 1975.

When in the area of Music Hall, Washington Park can be seen directly across the street, and it is a nice area for resting and quick explorations. Over 150 years old, it has been an urban space for generations and contains a large lawn and some historic gems. The park's bandstand stands out as a nice historical site, and the park itself includes many modern amenities for an enjoyable afternoon. Prior to serving as a park, the site held two burial fields. The site was purchased by the City of Cincinnati in 1855, and park construction began in the 1860s. The park was renovated and reopened after construction in 2011. During the park's renovation, remains of individuals were unearthed. They were reinterred at Spring Grove Cemetery. According to the web page of Gray & Pape, a historical architecture firm:

> *Analysis of archival records, cultural materials (including clothing items), engraved headstones and coffin/casket forms and associated hardware indicates the cemetery was in use as early as 1808 and remained active*

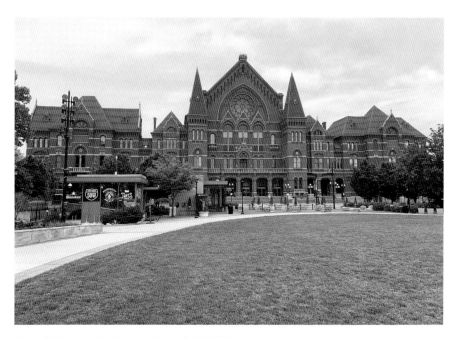

Music Hall from Washington Park. *Kevin T. Kelly*.

until 1855. Although most of the human skeletal remains were not well preserved, the excavated burials provided insights into mortuary practices during the early to mid-nineteenth century, as well as demographic information of those interred within its boundaries.

Memorial Hall

Located just south of Music Hall is Memorial Hall at Elm and Grant Streets. It is officially called the Hamilton County Memorial Building, and it was constructed in 1908 in remembrance of those from Cincinnati and Hamilton County who have served in the military. This Hannaford building contains 556 seats and was originally designed for speaking engagements. It is said an individual speaking on the stage can be heard in the back of the hall with no amplification. Today, it is used for concerts and other events. It was listed in the National Register of Historic Places in 1978 and underwent an extensive renovation in 2016.

Both Music Hall and Memorial Hall are conveniently located on the Cincinnati streetcar route.

Cincinnati City Hall

This Hannaford-designed building is four stories tall and contains a stately clock tower. It is located at 801 Plum Street and was built between 1888 and 1893. It is worth a visit, as inside, it contains stained-glass windows depicting Cincinnatus, "Queen of the West" and the early history of Cincinnati. Cincinnati's first city hall was built on this site and was demolished in 1888. "Cincinnati's City Hall represents the prevailing architectural tastes at the time of its construction and the influence of H.H. Richardson on its designer, Samuel Hannaford. Richardson's winning design for the Cincinnati Chamber of Commerce building was executed in the 1880s; however, the building's demolition in 1911 left city hall the best remaining example of Richardson Romanesque in Cincinnati."[17] Another source says, "An iron portcullis still peeks out over the steps where it once descended to close off city hall on Sundays or in

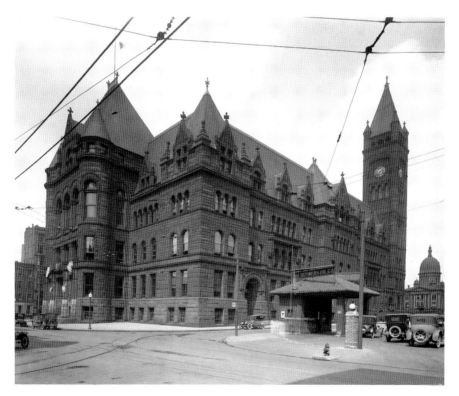

Cincinnati City Hall. *Courtesy of the Kenton County Public Library.*

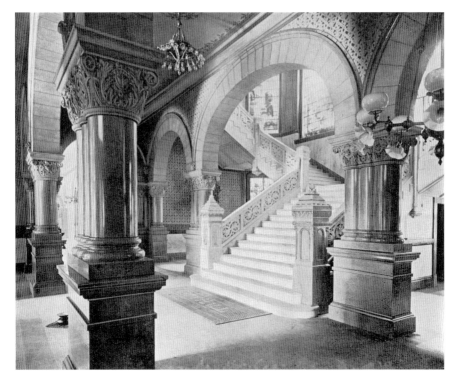

Cincinnati City Hall staircase. *From the collection of the Cincinnati and Hamilton County Public Library.*

the case of a riot."[18] According to the City of Cincinnati's web page about the history of the building, the large window that can be seen on the Plum Street side of the building references the Queen City in Longfellow's poem "Catawba Wine." Art and interesting details can be seen throughout the building. For example, on the Plum Street side of the building, there are two ceiling paintings that were completed in 1897 or later, one by Walter Beck. According to the city's web page, the other painting is in an office and was painted by Frank Duveneck and John Rettig.

Alms and Doepke Building

The Alms and Doepke Dry Goods building is a nice example of a commercial building designed by Hannaford in which the core of the building was built in 1878. This building housed a dry goods company founded in 1865 by William F. Doepke and his cousins William H. Alms and

Frederick H. Alms. At the time, it faced the Miami and Erie Canal, which ran from Cincinnati to Toledo, Ohio. This water route was very significant for transportation, as it created a route from the Ohio River to Lake Erie. As a side note: "Due to competition from railroads, which began to be built in the area in the 1850s, the commercial use of the canal gradually declined during the late 19th century. It was permanently abandoned for commercial use in 1913, after a historic flood in Ohio severely damaged it."[19] The Alms and Doepke building was built in stages via expansions in 1886, 1890 and 1906. The company closed its operation in 1955, and today, it houses Hamilton County offices. It is located at 222 East Central Parkway.

Across the street from the Alms and Doepke building is the Hamilton County Courthouse. It was not designed by Hannaford, but it is worthy of notice when in the area. Designed by Charles Howard Crane in the Beaux-Arts architectural style, it was dedicated in 1918. It is made of New Hampshire granite and Bedford limestone, and it has sixteen large columns on the front.

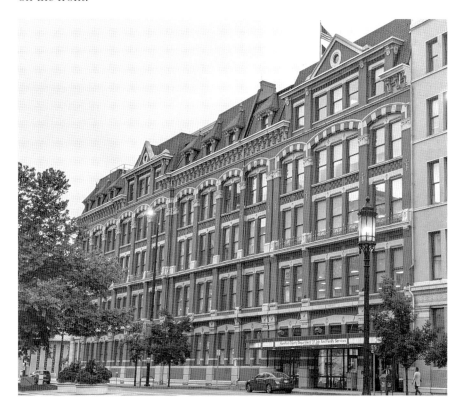

Alms and Doepke building. *Robert Schrage.*

Cincinnatian Hotel

The Cincinnatian Hotel was built in 1882, and it is located at Sixth and Vine Streets. Designed by Hannaford and Thomas Emery, it was originally called the Palace Hotel. At the time of its construction, it was Cincinnati's tallest building. Later, it became known as the Palace Cincinnatian, and in 1951, it was named the Cincinnatian. This was Hannaford's second French Empire design, and it features gabled windows and mansard roof. It was part of a movement to build "grand palace hotels."[20]

Phoenix Building

Located at 812 Race Street, the Phoenix building was constructed in 1893 as a location for a Jewish businessmen's organization. It is an Italian Renaissance style example of Hannaford's.

Times-Star Building

The Cincinnati Times-Star building is located at 800 Broadway and currently houses Hamilton County agencies. This building was designed by the Hannaford firm and was built in 1933. Samuel Hannaford died in 1911. This building is included here as an example of the Art Deco style and a lot of the outside façade contains tributes to the printing publishing business. It was bought by the county in the 1980s after it was occupied at different times by the *Times-Star* and later by the *Cincinnati Post*. There is no thirteenth floor, and the four pillars at the top represent patriotism, truth, speed and progress.

Elsinore Arch

In 1883, the Cincinnati Water Works wanted to construct a new water main from the Eden Park Reservoir to Gilbert Avenue. A valve house was needed to control the flow of water. It was desired that this area also serve as a new entrance to the park, which led to the design of the Elsinore Arch. The arch is said to have been inspired by Kronborg Castle from *Hamlet*. Samuel Hannaford's firm was used to design the arch; however, Charles

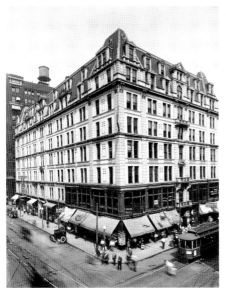

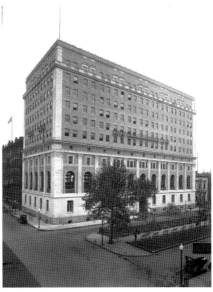

Above, left: Cincinnatian Hotel. *Courtesy of the Kenton County Public Library.*

Above, right: The Phoenix, circa 1924. *Courtesy of the Kenton County Public Library.*

Left: The Times-Star building. *Robert Schrage.*

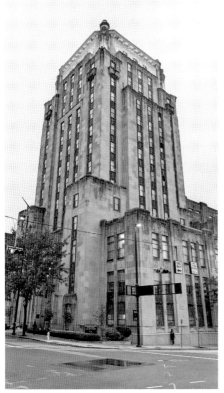

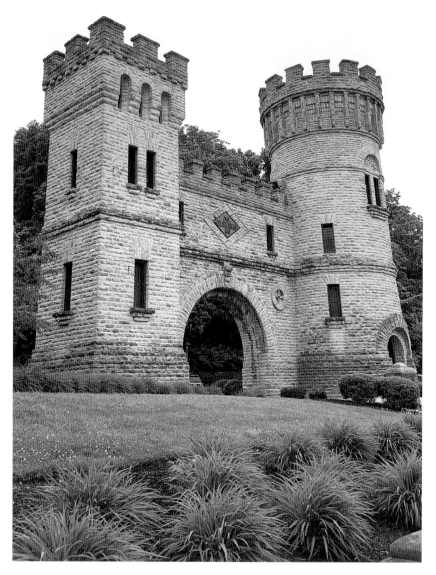

Elsinore Arch. *Kevin T. Kelly.*

B. Hannaford, Samuel's son, was the commissioned architect. It is of the Roman Romanesque Revival style and was constructed at a cost of $15,000. Behind the arch is easy access to the historic steps that lead toward the art museum. The art museum was founded in 1881, and the 1883 arch and steps served as a new entrance to Eden Park.

John Church Company Building

An interesting Hannaford designed structure is the John Church Company building, located at 14–16 East Fourth Street downtown. The building was once home to the Church Company, one of the country's leading merchants of sheet music and musical instruments.

> *Built in 1885 on a foundation of limestone, the John Church Company building is a primarily brick and stone structure in the Renaissance Revival style; its roof is rubber, and it features some elements of iron and steel. The five-story façade is divided into two sections of three bays, each with storefronts on the first floor and windows higher up and topped with a decorative cornice. Although one of its neighbors is just three stories tall, it is substantially smaller than many of the surrounding buildings.*[21]

Across East Fourth Street from the John Church Company building is an historical marker about the Cincinnati Stock Exchange (CSE), once housed in the nearby Dixie Terminal building. It is worth a quick visit. The plaque states that the CSE was founded in 1885 and "emerged as an innovator in stock trading when it started the nation's first computerized stock exchange in 1976." According to Investopedia: "The Cincinnati Stock Exchange was founded by several prominent Cincinnati businessmen in the year 1885, responding to the growing financial needs of the city. As more and more major businesses set up in Cincinnati, these merchants needed a way to publicly trade shares in the titanic industries. It quickly became the fiscal hub of the city. In

John Church Company building. *Robert Schrage.*

1976, its trading floor was shut down, and the market became all electronic, operating through telephones and computers."

Waterworks Buildings in Eden Park

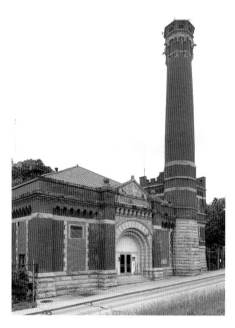

The historic structure called Eden Park Station No. 7 was constructed in the late 1800s as a part of the Cincinnati water supply system. For its original purpose, it was only used for several decades. Its construction started in 1889; however, it took five more years to complete. It is located at 1430 Martin Drive, near the Krohn Conservatory. It was added to the National Register of Historic Places in 1980. Hannaford freely designed in many different styles

Left: Eden Park Station No. 7. *Kevin T. Kelly.*

Below: Eden Park tower. *Courtesy of Kenton County Public Library.*

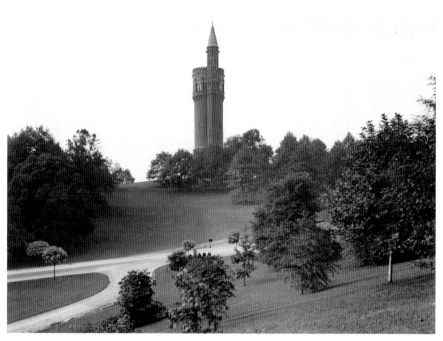

that were popular in the late nineteenth century. "The Eden Park Station is typical of these, exhibiting features of the Neoclassical, the Queen Anne, and the Romanesque Revival styles. Although the walls of the building and its associated chimney are brick, the building rests on a stone foundation, and the roof is tiled. Sandstone is employed for decorative arches placed underneath a Neoclassical pediment to form the frontispiece. The tallest parts of the station are four stories tall."[22]

During the time of design and construction of Station No. 7, Hannaford also designed the Eden Park Standpipe Tower. The 172-foot-tall structure sits on Cliff Drive. These two structures pumped water from the reservoir to nearby neighborhoods.

Jobs Corp Building (Old Our Lady of Mercy High School)

Designed by Hannaford in 1897, this building once housed Our Lady of Mercy High School. It sits near the entrance to Union Terminal on the west end of downtown.

Jobs Corps building. *Ann Schrage.*

Cincinnati Observatory

The Cincinnati Observatory is located at 3489 Observatory Place in a neighborhood of historic homes. The Cincinnati Observatory is known as "the birthplace of American astronomy" and houses one of the oldest working telescopes in the world. It was the first public observatory in the western hemisphere.[23] Originally located on Mount Ida (Mount Adams), the observatory moved to this location in 1873. The area, called Mount Lookout, was so named because of the observatory. The 1873 building was designed by Hannaford. The observatory was moved to this location in part to get away from the smog of the city that clouded the skies. There are actually two buildings at this site: the 1873 building and a smaller structure called the Mitchel building. The Mitchel building houses the original telescope from Mount Adams.

Spring Grove Cemetery

Spring Grove is a cemetery and arboretum located at 4521 Spring Grove Avenue. Its charter dates to 1844 and houses a Samuel Hannaford–designed chapel near the gates of the cemetery and, further back, the White Pine Chapel. The Norman Chapel was built in 1880 of limestone and sandstone. Its features include stained-glass windows. The chapel originally housed a jail in the basement and is of the Romanesque Revival style. The White Pine Chapel was constructed in 1859 and served as a receiving vault. Before burials were held elsewhere in the cemetery, individuals were placed in this cold chapel. This is also where George Reeves of TV *Superman* fame was buried for about a year. He died in 1959 of a gunshot wound. His maternal grandparents were buried in Spring Grove. Reeves's mother wanted him buried in a mausoleum on the same plot as her parents, but there was no room to construct a mausoleum on the plot. Eventually, he was cremated, and his ashes are now interred in Pasadena, California.

Hannaford himself is buried at Spring Grove in section 110. However, the grave is unmarked. It appears his marker/monument no longer exists.

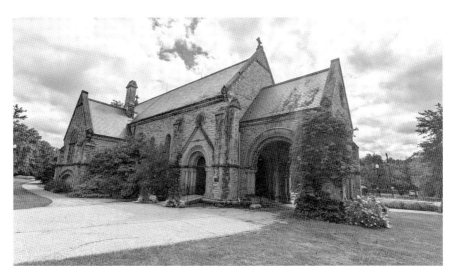

The Norman Chapel. *Robert Schrage*.

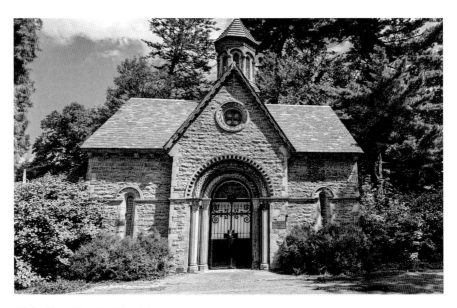

White Pine Chapel. *Robert Schrage*.

The Probasco Fountain

The Probasco Fountain is located near the postal address of 3704 Clifton Avenue (near the intersection of Clifton and Woolper Avenues). It was originally dedicated in 1887 and rededicated in 2015. According to the historical marker:

> *A gift from Henry Probasco to the People of Clifton, the fountain was designed by Cincinnati architect Samuel Hannaford and was inspired by the 16th-century fountains in St. Peter's Square, Vatican City. Originally set within Clifton Avenue to provide drinking water for horses, dogs and people, the fountain was relocated to its current location to improve accessibility and public safety. A marker in the sidewalk shows the center point of the original location. The fountain is listed in the National Register of Historic Places.*

Henry Probasco, a wealthy Cincinnati businessman, also donated the Tyler Davidson Fountain to the city.

Boss Cox and Samuel Hannaford

One of the most colorful figures in Cincinnati history is George B. Cox. Boss Cox was the political boss of Cincinnati. The only time he held political office was after his election to Cincinnati City Council in 1879. Typical of most "bosses," his power came from nonelected offices and was behind the scenes. He controlled the schools, the police and fire departments. According to an article on Cincinnatihistory.org by Tim Burke:

> *Having won the confidence of Ohio's highest-ranking Republicans as the county party chair, Cox was appointed to Cincinnati's Board of Public Affairs, a new body created in 1886 by the Ohio General Assembly to centralize Republican control over local patronage jobs. Once appointed to the board, Cox controlled more than 2,000 such jobs, giving him unprecedented control and influence in governing Cincinnati. His influence extended into the school board, the public waterworks and county government as well.*

How close were Hannaford and Cox? Again, according to Burke:

> *Though nothing exists explicitly stating Hannaford was given special consideration, relationships and loyalty carried a tremendous amount of*

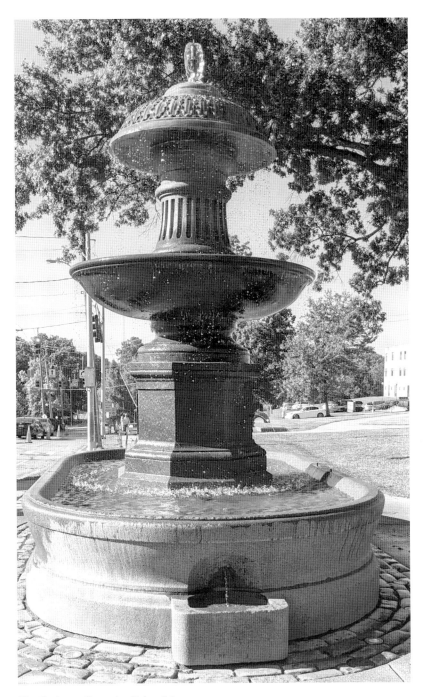

The Probasco fountain. *Robert Schrage*.

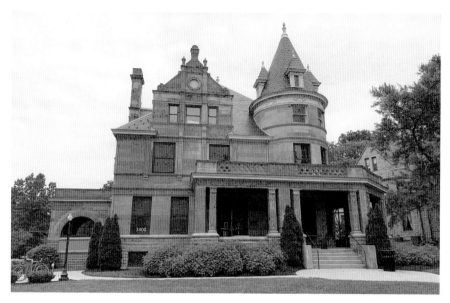

Boss Cox House. *Kevin T. Kelly.*

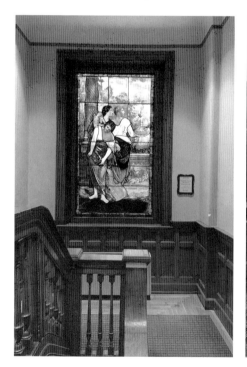

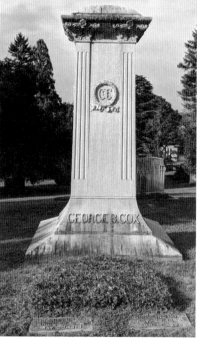

Left: A stained-glass window in the Boss Cox house. *Kevin T. Kelly.*

Right: Boss Cox's grave. *Robert Schrage.*

weight in the age of political machines. Nothing in Cincinnati happened without the approval of Cox or his lieutenants. A steady stream of contracts went Hannaford's way: the Eighteenth District Public School (1882), Elsinore Castle (1883, waterworks), Eden Park Pumping Station (1889), Eden Park Water Tower (1894), University of Cincinnati's McMicken Hall (1895), Van Wormer Library University of Cincinnati (1901), Cincinnati Police Station no. 5 (1896) in addition to city hall and designing Cox's own stately mansion in 1895.

The Cox mansion is located at Brookline and Jefferson Avenues in the Clifton area of Cincinnati and was called Parkview. It was designed by Hannaford toward the end of his career. Hannaford retired in 1897. The house is generally made of sandstone with a stone foundation. This house is typical of those built by Hannaford. "Many of his buildings, including the majority of the houses that he designed in Cincinnati, were constructed as the homes of wealthy or powerful members of the city's society; numerous rich and famous individuals of the Gilded Age found his style highly attractive."[24]

Cox died in 1916, and the house now serves as a branch of the public library of Cincinnati and Hamilton County. It is easy to visit the house and explore its features, including the windows, large porch and turret.

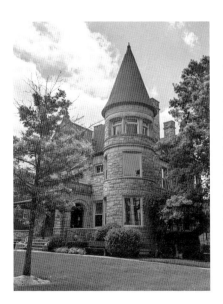

Captain Stone House

The Captain Stone House, located at 405 Oak Street, is a typical Hannaford home, with a turret, large gable and stone foundation. Built in 1890, the Romanesque Revival home was built for George Stone and his wife, Martha. Martha was a *Titanic* survivor. George was a U.S. Civil War officer and, after he moved to the city, an important Cincinnati businessman.

Captain Stone House. *Robert Schrage.*

Mitchell Mansion

This mansion was built in the early 1880s for Richard H. Mitchell and is located at 3 Burton Woods Lane. It was called Enniskillen after the hometown of his immigrant Irish father. Today, it houses programs of the New School Montessori. The family occupied the home until 1927. The building is two and a half stories tall and built of stone with a typical Hannaford turret, gabled roof and outstanding porch.

The remainder of this chapter will look at three examples of Hannaford's church work. He worked on dozens of churches and chapels over his career. Two from Spring Grove Cemetery were previously discussed.

Nast Trinity Church

The Nast Trinity Church is now known as the Warehouse Church and is located in Over-the-Rhine at 1310 Race Street. Constructed in 1880, it was the home of the first German Methodist Church established anywhere in the world.[25] German immigrant William Nast, starting in Cincinnati in 1837, began organizing Methodist churches in the United States. In 1958, Nast and Trinity Methodist Churches merged and combined their names.

Saint George's Catholic Church

Saint George's Church is located near the University of Cincinnati and opened in 1873. Of the Romanesque Revival style, the building cost $80,000 to construct. The Catholic church was closed in 1993. Today, the building houses a location of Crossroads Church and is located at 42 Calhoun Street.

Walnut Hills United Presbyterian Church

All that remains of this church in the Walnut Hills neighborhood of Cincinnati is its historic tower. It is located on Madison Road and is a beautiful example of Hannaford's work. Built in 1880, the church was demolished due to years of neglect. However, the tower was saved by preservationists and today stands as an example of an innovative way to salvage something out of the loss of a historic structure.

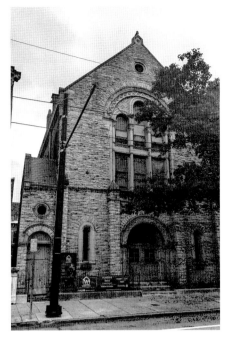

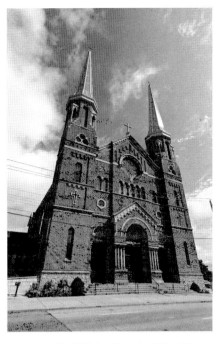

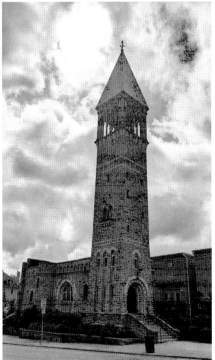

Above, left: Nast Trinity Church. *Robert Schrage*.

Above, right: Saint George's Catholic Church. *Robert Schrage*.

Left: Walnut Hills Church tower. *Robert Schrage*.

CONCLUSION

It is evident Hannaford utilized a lot of different styles in his work. His impact on Cincinnati's architecture is clear and visible. It is suggested, if interested, that the reader conduct a web search of other existing Hannaford structures. There are far too many to detail in this guide, but it would be easy to discover other samples around town and across the Ohio River in northern Kentucky. There is always more history to discover, and Hannaford sites always provide something to find.

ARCHITECTURE AND HISTORIC STRUCTURES

This chapter will highlight additional architectural examples throughout the city and will visit some historic structures that are less architecturally significant but represent important parts of Cincinnati's history. As a diverse and growing community, Cincinnati was influenced by various styles of architecture and the tastes of its immigrant population. However, many of these early structures are long gone, and those identified in this chapter are primarily from the early to mid-twentieth century. Chapter 5 will explore the Over-the-Rhine area of Cincinnati, where many historic structures still exist.

ASSORTED BUILDINGS

Although most of the buildings discussed in this section were built for private business purposes, some exceptions exist. Let's start with Cincinnati's most famous tower.

Carew Tower

For many years, the Carew Tower was the tallest building in downtown Cincinnati. It is now the second tallest at forty-nine stories. In 1994, it was placed in the National Register of Historic Places. The forty-ninth story was

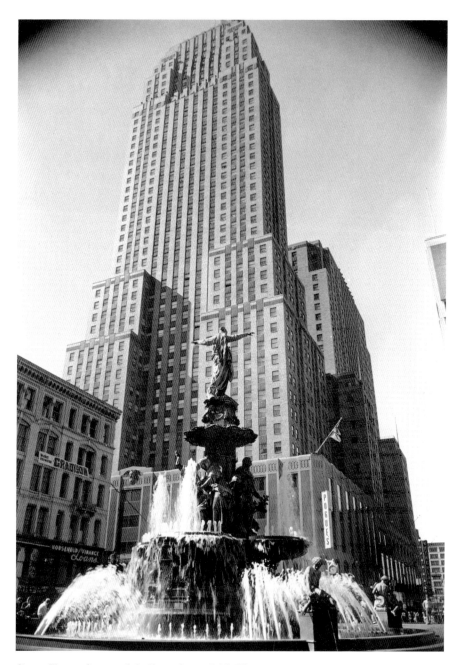

Carew Tower. *Courtesy of the Kenton County Public Library.*

for years an observation deck. The building is named after Joseph T. Carew, who died in 1914 and was the owner of Mabley & Carew Department Stores. The tower cost $33 million to erect. The Thomas Emery Company bought the existing Mabley building on the site and, in 1929, announced plans for the new skyscraper.[26] Construction began one month before the Wall Street crash of 1929. It was designed in the Art Deco style. To fully appreciate the building, it is important to go inside and look around. Interestingly, A.B. Chandler, a former and future governor of Kentucky, had his office in the Carew Tower while he was commissioner of Major League Baseball from 1945 to 1951. National League president Warren Giles had his office in the tower in the 1950s and 1960s.

Contained within the tower is the Hilton Cincinnati Netherland Plaza, traditionally called the Omni Netherland. This is a beautiful hotel built in the Art Deco style and is a must-see on the inside. It has been a notable site since 1931 and is located at Fifth and Race Streets.

Fourth and Vine Tower

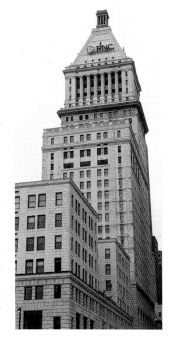

One of the most visible and recognizable buildings in Cincinnati is the Fourth and Vine Tower, unofficially called the PNC Tower. It is located at 1 West Fourth Street. The tower is thirty-one stories tall, and the top of the building is what makes this a truly spectacular building. Take note of the "wing to the elaborate Hellenic architecture in the upper portion of the tower, which was modeled to resemble reconstruction of the Mausoleum at Halicarnassus."[27] When the tower was constructed in 1913, it was the fifth-tallest building in the world and second-tallest office building outside of New York City.[28] Previously housed at different times at this site were the chamber of commerce building, post office and customs house.

Fourth and Vine Tower. *Robert Schrage.*

Dixie Terminal Building

The Dixie Terminal was completed in 1921 and has been used for many different purposes, including as a streetcar terminal, bus terminal, office building and the Cincinnati Stock Exchange. A beautiful arcade runs through the building, starting at the main entrance on Fourth Street. It includes Bottincino marble wainscot, metal trimmings and "costly brightly decorated ceilings, with fanciful medallions showing little children riding on the backs of various animals."[29] "The Cincinnati Stock Exchange closed its physical trading floor in 1976, after becoming an all-electronic stock trading exchange but remained in the building until relocating to Chicago in 1995 as the National Stock Exchange."[30]

Ingalls Building

The Ingalls building was built in 1903 and is the world's first reinforced concrete skyscraper. At the time of its construction, it was a bold undertaking, and "many people from both the public and the engineering community believed that a concrete tower as tall as the plan for the Ingalls building would collapse under wind loads or even its own weight. When the building was completed and the supports removed, one reporter allegedly stayed awake through the night in order to be the first to report on the building's demise."[31] It is located at Fourth and Vine Streets downtown.

German National Bank

Just across Vine Street from the Ingalls building is the German National Bank building. This building was constructed in 1904 in the Biblioteque Sainte-Genevieve style. Due to anti-German prejudice during World War I, the name of the bank was changed to Lincoln National Bank.[32]

Taft Theatre and Masonic Center Buildings

The Taft Theater, located at 317 East Fifth Street, was built in 1928 and has an Art Deco–style lobby. It is a 2,500-seat theater with Neo-Classical/Art Deco architecture and houses concerts, shows and other events.

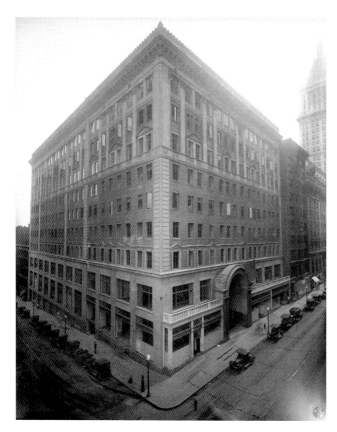

Left: Dixie Terminal building. *Courtesy of the Kenton County Public Library.*

Below: German National Bank. *Robert Schrage.*

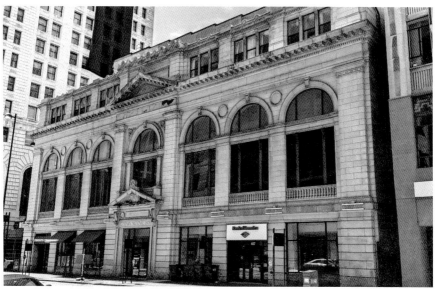

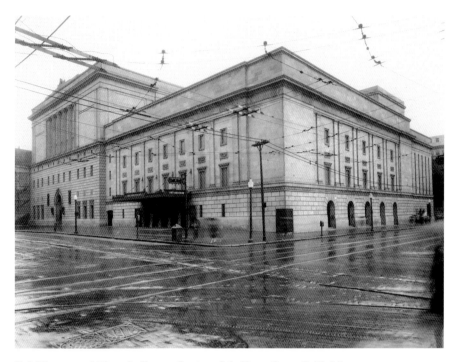

Taft Theatre and Masonic Center. *Courtesy of the Kenton County Public Library.*

It is attached to the Masonic Center. A cornerstone dedication for the center occurred on October 20, 1926, and a full dedication occurred on January 26, 1928. According to their website, "The Cincinnati Masonic Center is located downtown, right next to the Taft Theatre. This historical building is home to the Valley of Cincinnati, the local branch of the Ancient Accepted Scottish Rite of Freemasonry. It houses Children's Dyslexia Centers of Cincinnati, a 501(c)(3) nonprofit, as well as Masonic Lodges and other organizations that are connected to the Masonic fraternity."

Procter & Gamble Buildings

Directly across the street from the Taft Theatre is the world headquarters of the Procter & Gamble (P&G) Company. This international company was founded in Cincinnati in 1837 by William Procter and James Gamble. Procter was a candle maker, and Gamble made soap. Both immigrated to Cincinnati from England and Ireland, respectively. They married sisters. It was through the sisters that they met.

P&G Plaza is a nice spot to visit and relax in downtown. The concrete towers were built in 1985 and are considered postmodern. The façade material is limestone, and the buildings stand at just over 228 feet tall. On this site is the One Procter & Gamble building, constructed in 1956.

Great American Tower

The Great American Tower is the largest skyscraper in Cincinnati, standing at 665 feet tall with 41 stories. Construction began in 2008 and was finished in 2011. According to Emporis, a provider of international skyscraper data, "This building surpassed the Carew Tower to become the city's new tallest and ended Cincinnati's long reign as the largest U.S. city whose tallest building ever built was completed prior to World War II."

"The building's architect, Gyo Obata, designed the building to include a top inspired by Diana, Princess of Wales's, tiara. Gyo was flipping through books when he came upon a picture of Diana wearing a crown. 'That's perfect. Here we have the crown of the building, and the nickname for the city is Queen City,' said Joe Robertson of Hellmuth, Obata and Kassabaum remarking to Gyo when he first saw the picture."[33]

Guilford School Building

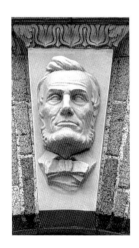

Lincoln's face at Guilford. *Robert Schrage.*

The Guilford School building was dedicated on May 16, 1914, and was named for Nathan Guilford. Guilford was the first superintendent of schools in Cincinnati and an early champion of public education. Not only is the building a piece of historical architecture, but the land is very significant. It stands on a part of the original Fort Washington, and the spot is marked by a historical stone monument, which rests on the east side of the parking lot toward Lytle Park, originally dedicated in 1901. Also, Stephen Foster lived in a house on the site from 1846 to 1850. Foster composed such classics as "My Old Kentucky Home," "Swanee River" and "Old Black Joe." One of his most famous pieces, "Oh! Susanna," was written in Cincinnati. A plaque

Guilford School building. *Robert Schrage.*

on the building recognizes this piece of Foster history. One of this author's favorite overlooked gems sits above the two main entrances of the building. One is a bust of Lincoln, and the other is a bust of Washington.

The Kroger Building

The Kroger building at 1014 Vine Street was the first major commercial building built in Cincinnati after World War II. It is located ten blocks from the Ohio River and was completed in 1958. This building is the national headquarters for the Kroger Company, founded in Cincinnati by Barney Kroger in 1883. In 1883, Kroger was only twenty-three years old when he invested his life savings of $223 to open a grocery store, the Great Western Tea Company. He had a simple motto: "Be particular, never sell anything you would not want yourself." Kroger died in 1938 and was buried in Spring Grove Cemetery.

The concrete building has an aluminum exterior. According to Emporis, the building's façade was blue and white at construction but during a 1980 renovation, it was updated to a new "aluminum skin."

Kroger building. *Courtesy of the Kenton County Public Library.*

Herzog Studios

Located at 811 Race Street, the Herzog Studios Recording Company was housed on the second floor. It was founded by E.T. "Bucky" Herzog, and at the time, it was the only commercial recording studio in Cincinnati. A historical marker can be found at the location. It mentions that "as a WLW engineer, Bucky worked with King Records, WLW radio musicians, and visiting performers. Performers such as Flatt & Scruggs, Bull Moose Jackson, The Delmore Brothers, Patti Page, and Hank Williams were recorded here." On another side, the plaque reads: "On December 22, 1948, Hank Williams came to Herzog Studios to record with WLW's Pleasant Valley Boys, the most in-demand session musicians in country music. They cut 'Lovesick Blues,' which launched Hank's career into superstardom and led to his invitation to join the *Grand Ole Opry*. After a second session on August 30, 1949, eight Hank Williams classics were recorded at Herzog, including 'I'm So Lonesome I could Cry.'" This is a must-see for a lover of music history.

King Records

Another significant music location is the home of King Records from 1943 to the early 1970s. This building was in disrepair for many years and barely survived demolition. Through the leadership of the city, renovations saved this historic structure. A historical marker was placed at the site by the Rock and Roll Hall of Fame in 2008. It reads: "From 1943–1971, King Records forever changed American music. Owner Syd Nathan gave the world bluegrass, R&B, rock and roll, doo-wop, country and soul and funk. With stars from James Brown to the Stanley Brothers and its innovative integrated business model, Cincinnati's King Records revolutionized the music industry." The studio building is located at 1540 Brewster Avenue.

Crosley Square

Originally an Elks lodge, this building became Crosley Square when it was opened as the studios of WLW Television in 1948. Many classic Cincinnati television shows were broadcast out of this building, including the *Bob*

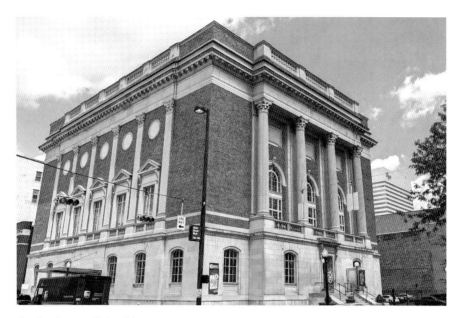

Crosley Square. *Robert Schrage.*

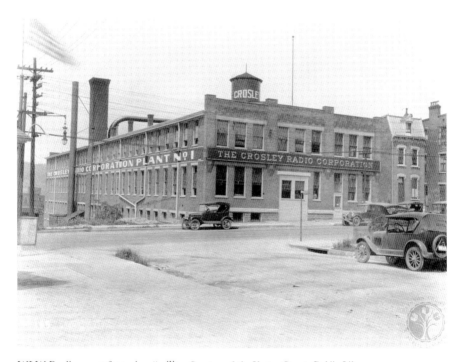

WLW Radio manufacturing facility. *Courtesy of the Kenton County Public Library.*

Braun Show, *Paul Dixon Show* and *Ruth Lyons 50-50 Club*. Its last broadcast was held in 1999, when WLW moved to a new location. According to the *Queen City Tours* blog: "When World War II started, the Crosley radio manufacturing facility became highly classified, due to the fact that Crosley was making detonators for the military. The Crosley executives purchased the old Elks lodge on Ninth and Elm and made it the broadcasting center for the Midwest." The old manufacturing facility is located on Arlington Street.

Powell Crosley is a Cincinnati legend, and in addition to radios and broadcasting, he manufactured automobiles. He was an owner of the Cincinnati Reds and was called "the Henry Ford of radio." He was buried in Spring Grove Cemetery.

Rookwood Pottery

Rookwood Pottery was founded in 1880 by Maria Longworth Nichols Storer. Its first pottery location was on Eastern Avenue. The second and more famous building was built in 1891–92 in Mount Adams. It was designed by H. Neil Wilson; however, the building was later expanded in 1899 and 1903. The company closed in 1967 but was reopened in Over-the-Rhine in 2004. Rookwood Pottery was a well-renowned manufacturer of American art pottery, which, according to the Wikipedia definition, refers to "aesthetically distinctive hand-made ceramics in earthware from the period 1870–1950s." Rookwood was influenced by Japanese and French ceramics and was "known for experimenting with glazes and for the exceptionally high quality of the painted and incised work."[34]

The Mount Adams building is located at 1077 Celestial Street. It is a half-timbered structure, and in recent years, it has been home to several restaurants.

125 East Ninth Street Building

This small building is not particularly well known, but it was an interesting find for this author while walking around downtown. Built in 1890, it housed the former Republican Club. On the façade are well-executed sculptures of an eagle and, on each side of the doorway, two elephants. On the bottom left of the door, it reads: "Dedicated to the Republican Party A.D. 1928."

This page: Rookwood Pottery. *Courtesy of the Kenton County Public Library*.

East Ninth Street building. *Robert Schrage*.

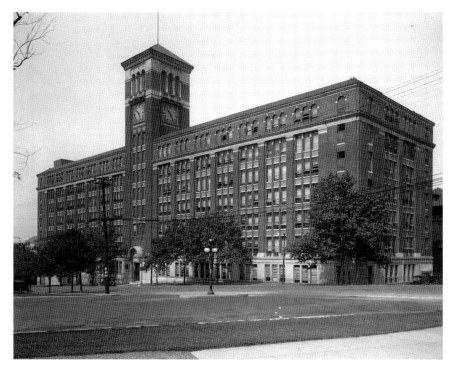

Baldwin Piano Company. *Courtesy of the Kenton County Public Library.*

Baldwin Building

The Baldwin building is located on Gilbert Avenue near Eden Park Drive. It was home to Baldwin Piano and its two thousand employees. Built in the early 1920s, it produced eleven thousand pianos in its first five years. It was built in the Italian Renaissance style and is highlighted by a large clock tower and rounded arch openings.[35] Baldwin operated in this building until 1961.

The Woodward Theater

The Woodward was built as a theater in 1913 in the Beaux-Arts style. It was originally a silent movie house and was named in honor of William Woodward, who, in 1796, purchased the land where the building is located. It sits at 1404 Main Street downtown and is one of the few old theaters that still exists there. Main Street is home to many historic structures, and this small theater is a unique piece of architecture.

The Woodward. *Ann Schrage*.

The Gwynne Building

Located at Sixth and Main Streets is the Gwynne building, completed in 1914. From 1935 to 1956, this building housed the headquarters of Procter & Gamble.

Mercantile Library

The historic library is mostly on the eleventh floor of the Mercantile Library building at 414 Walnut Street. A historical marker sits at the building's entrance. The library has been at this address since 1840. It was chartered in 1835 and has a remarkable history. The current building is the fourth to be constructed on the site and was completed in 1903. It was designed by Joseph and Bernard Steinkamp. According to the library's website, forty-five young merchants started the Young Men's Mercantile Library Association in Cincinnati. Keep in mind that at this time, Cincinnati was no more than a growing town on the western front of America. According to the library's website:

> *The chief instigator behind founding Cincinnati's Mercantile Library was a junior partner in the grocery firm of Worthington and Ranney, one Moses Ranney, a boarder at the Dennison Hotel. He and his fellow bookworms*

started with $1,800 and 700 books. They first met over a fire house, then rented a room near Pearl Street, the site of the city's first public market. In the beginning, they struggled to build a membership that could pay sufficient dues to meet their costs, but as their ranks and collection grew, the library found stability and commodious quarters in the Cincinnati College building on Walnut Street.

Today, the library is still a member's-only association, but non-members can visit the eleventh floor. As part of the library's long history of dedication to public engagements, it hosts a wide range of speakers. Over its many years, it has hosted individuals such as Herman Melville, Harriet Beecher Stowe, William M. Thackeray and Ralph Waldo Emerson. An association steeped in history, the library continues to be a unique and important part of the community. A visit to the library is a nice step into the history of Cincinnati.

While at this location, look for the historical marker titled "Public Square." It is located to the left of the building's entrance and discusses the site of the original Hamilton County Courthouse, First Presbyterian Church and Cincinnati College.

Henry Wielert's Beer Garden

The restored Henry Wielert Beer Garden is located at 1410 Vine Street. This is where Boss Cox conducted city business in the late 1800s. According to the web page for the Gnarly Gnome:

1410 Vine Street was built in 1873 and is packed full of more stories that I can possibly hope to tell you. The café once hosted the city's largest beer garden behind it that stretched an entire city block. The orchestra that used to play in the beer garden became

Wielert Beer Garden. *Ann Schrage.*

the Cincinnati Symphony Orchestra. The balcony that overlooked the beer garden was where the World Series was conceived, the space next door was where Ezzard Charles trained as a boxer. It's from a personal table at Weilert's that Boss Cox ran the city (and his business empire).

Today, it houses a bar and restaurant.

Cincinnati Bell Company Building

This building will be most appreciated for the carvings on its façade. Located 209 West Seventh Street, the Art Deco building opened in 1931. According to the history of the building, written by AltaFiber (formerly known as Cincinnati Bell), "At the time, it housed the world's longest straight switchboard, with over 88 operators. The building was built in such a way as to protect the city's phone network. With a push of a button, heavy steel doors will lock and metal covers will spring up over the windows on the lower floors." The twelve-story building façade is made of limestone and marble. It also contains beautiful wrought metal art.

The building has many details, and Cincydeco.com says it is "like a gallery in the streets." The façade includes art depicting mass communications and industrialization. The four carved stone bas-reliefs are of the four elements of earth, air, fire and water.

Carved art on the Telephone Company building. *Robert Schrage.*

CHURCH EXAMPLES

Cincinnati is blessed to have many churches of historical significance. Some will be discussed in other parts of this guide and can be found scattered around the community in the various neighborhoods. This section will focus on a handful of churches, most of them located downtown, that are both significant and among this author's favorites.

Cathedral Basilica of Saint Peter in Chains

Cathedral Basilica of Saint Peter in Chains is a Greek Revival church at Eighth and Plum Streets. The cornerstone was laid in 1841, and the church was dedicated in 1845. It was conferred a Minor Basilica by Pope Francis in 2020. The tower is made of limestone and rises 224 feet. The columns are 33 feet tall and symbolize the number of years in Jesus' life.[36] "The interior of St. Peter in Chains is distinctly unique among Roman Catholic cathedrals in America, with its Greek-themed mosaics depicting the Stations of the Cross, its ornate Corinthian columns and its massive bronze doors. The crucifix is by Benvenuto Cellini, the murals by Carl Zimmerman, and the mosaic in the apse is the work of Anton Wendling."[37]

The cathedral hosted Polish archbishop Karol Wojtya in 1977. He became Pope John Paul II the following year.

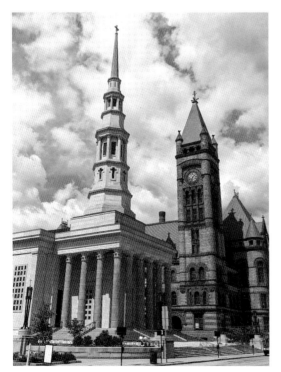

Saint Peter in Chains next to city hall. *Robert Schrage.*

Saint Francis Xavier Church

Located at 611 Sycamore Street, the first diocesan cathedral of Cincinnati was located at this site. Saint Francis Xavier lost this designation when the cathedral was moved to Saint Peter in Chains in 1845. This current building was erected between 1858 and 1861. The cathedral is very important to Cincinnati, as the lot to the north of the church is the location of a college named Athenaeum. In 1840, it was renamed Saint Xavier College. A historical marker at the site reads, "This institution evolved into today's Xavier University, which moved to its Evanston-Avondale campus in 1919." The actual date of this move is 1912.

Old Saint Mary's Church

Old Saint Mary's Roman Catholic Church is the oldest church building in Cincinnati. According to the church's website, "In 1840, German immigrants were arriving in Cincinnati at the rate of 200 per day. Many of the men donated their own labor to build the church, making the bricks by hand." The steeple is the oldest clock tower in the city and contains the first bell to be installed by the Verdin Company.[38] The church building was dedicated on July 3, 1842, and its first service was then held. The Greek Revival building is 142 feet long and 66 feet wide. At the time of its construction, it is said to have been the largest church in the Ohio Valley. It is the second-oldest German parish in the city. Today, it is still active, and its masses are still conducted in Latin, English and German.

Christ Church Cathedral

Founded in 1817 by missionary Philander Chase and others, including future president William Henry Harrison, Christ Church Cathedral is a cathedral church of the Episcopal Diocese of Southern Ohio. The church moved to its present location at 318 East Fourth Street in 1835. This building was demolished and replaced in 1957. There is a Gothic Revival parish house on site that was constructed in 1907. A small "Centennial Chapel" is located north of the cathedral and is used for many purposes, such as smaller services and concerts. On Palm Sunday 1993, Christ Church was consecrated the cathedral of the Episcopal Diocese of Southern Ohio, succeeding the former St. Paul Episcopal

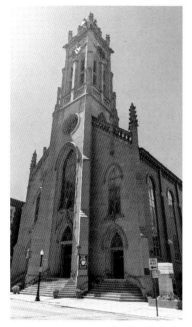

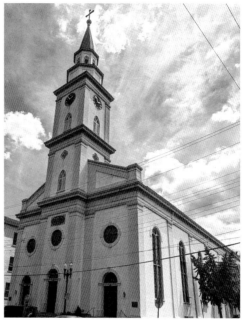

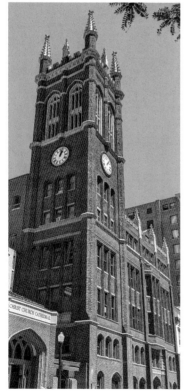

Above, left: Saint Francis Xavier Church. *Robert Schrage.*

Above, right: Old Saint Mary's Church. *Robert Schrage.*

Left: Christ Church Cathedral. *Robert Schrage.*

Cathedral in Cincinnati. Christ Church is very active and provides a wide range of services for the community, including concerts, health and wellness, youth events, speakers and the annual Boar's Head and Yule Log Festival. The festival has been held since 1940 and is a must-see for history lovers.

Saint Francis Seraph Parish

To set the stage for the presence of so many German Catholic churches in the community, it is important to mention Saint Francis Seraph Parish's sheer numbers. According to the parish's web page:

> In the middle of the 19th century, the area of Cincinnati now called Over-the-Rhine was a bustling, crowded neighborhood filled with businesses, factories and homes. Here, the great waves of German immigrants had come to settle, raise families and worship together. Many of them were Catholic, so many that by the time St. Francis Seraph Church was under construction in 1859, there were already eight German Catholic congregations. The largest of these, St. Johns, had over 700 families, with over 400 baptisms a year.

During this time, the cornerstone for the current Saint Francis Seraph Parish was laid in November 1858. This church is magnificent due to its ornate decorations favored by German immigrants, two large church bells, a bronze statue of Saint Francis over the church doors and frescoes and large paintings.[39] A catholic cemetery was located next to the new Saint Francis Seraph Parish. When the new church was built, bodies were entombed in a crypt below the altar.

> A major change in the church building took place in 1907, coinciding with the building of a larger residence for the friars. The rear of the sanctuary was removed, and a choir for the friars added, connecting with the friary. A new high altar, under a massive canopy or baldachino, was added. In 1912, a Grotto of Our Lady of Lourdes was constructed in the rear of the church. In 1914, the entire church was redecorated for a fifth time. In 1925, extensive improvements to the exterior of the church resulted in the distinctive veneer of glazed brick, which looks reasonably fresh nearly 85 years later.[40]

Today, Saint Francis Seraph Parish has a tremendous focus on social issues. Saint Francis Seraph Ministries was created and is sponsored by the

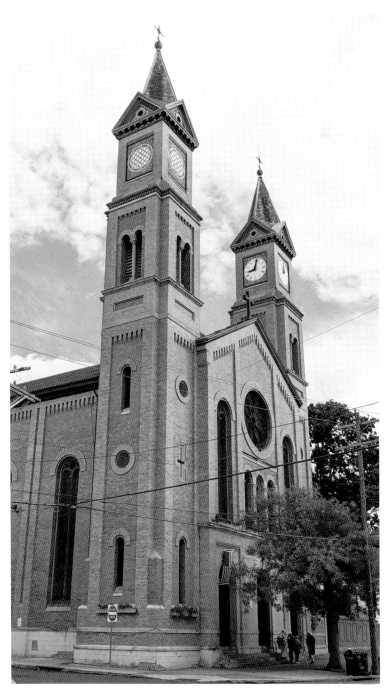

Saint Francis Seraph Parish. *Robert Schrage.*

Francian friars. The friars, the school and the parish are all serving the Over-the-Rhine community and are making a difference in the lives of those in need. The parish is located at 1615 Vine Street.

Covenant First Presbyterian Church

The Covenant First Presbyterian Church, located at 717 Elm Street, is the result of mergers over an extended period. The present church building was dedicated on April 11, 1875. It was constructed at a cost of $250,000.

> *It was designed by Cincinnati architect William Walter. The Gothic-style church was constructed, facing Piatt Park, of handcut stone from the quarries of church member Colonel Peter Rudolph Neff. The belfry remains as originally constructed and contains a huge bell bearing the old inscription in bold relief, "Revere, Boston." The unusual interior arrangement is said to have its origin in the seventeenth-century Gothic tithing-barns of the Scottish-English border country. The pulpit furniture was carved from black walnut by Henry L. Fry.*[41]

Saint John's German Protestant Church
(Apostolic Bethlehem Temple Church)

Located at 1205 Elm Street, this German Gothic Revival building was constructed in the late 1860s. In the center of the front façade is a tower with the church entrance at its base. According to *Cincinnati Over the Rhine*, written by Robert J. Wimberg, "St. John Church, the oldest German congregation in Cincinnati, began in 1813, when, on October 10, Rev. Joseph Zaelein baptized Pierson Heckewelder, the first German child born in Cincinnati. By 1867, the congregation had outgrown its old church. The church on this site was erected according to the design of Sigmund Kutnitzky." In modern times, St. John's was moved to Clifton, and the building was purchased by the Apostolic Bethlehem Congregation. Also, Wimberg said, "This church rests upon the ground which in the 1820s was Mundhenk's Hops Garden. When the Marquis de Lafayette visited Cincinnati in 1825, Carol Mundenk renewed her acquaintance with him. When she was a milkmaid in Europe, she had secretly given Lafayette a note while he was imprisoned at Olmutz and helped him to escape."

Immaculata Church (Mount Adams)

The Immaculata Church was built in 1859 high on a hill in Mount Adams at 30 Guido Street. It can be seen from many directions in Cincinnati, as it overlooks the river and downtown Cincinnati and is such a staple to the hillside. The cornerstone was laid by Cincinnati's first archbishop, John Baptist Purcell. According to Ed Adams, writing in one of the church's 150 historical articles, "The proliferation in the 1840s of the Over-the-Rhine churches in particular was attributable to the huge influx of Germans into Cincinnati in the 1830s and 1840s. The congregations of those churches were largely German. By 1840, native Germans constituted 31 percent of the city's population. The establishment of Immaculata, to serve the Germans of Mt. Adams, continued that trend. Not until 1872 was Holy Cross Church built to serve the Irish of Mt. Adams." Inside the church are

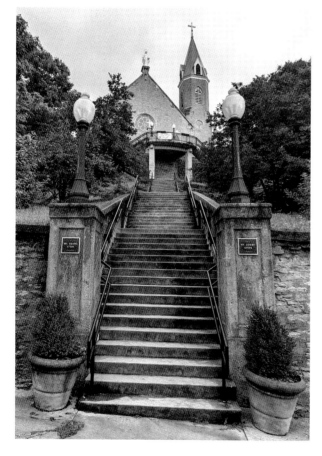

Immaculata Church and steps. *Robert Schrage.*

seven paintings by the famed artist Johann Schmitt. In 1977, the nearby Irish monastery closed, and its parishioners came to Immaculata. Thus, the church was named Holy Cross–Immaculata Parish.

It is the steps of this church that inspire many people. For well over one hundred years, pilgrims have come to pray the steps and rosery. It is one of Cincinnati's most cherished and beloved traditions. According to the church's history on its website:

> Year after year on Good Friday, thousands of pilgrims of various faiths have been praying "the Steps" of Mt. Adams to Immaculata Church. How did this unique devotion begin? It goes back to the saintly Archbishop Purcell, who, with great fervor, urged the faithful of Cincinnati to pray for his grand venture—a shrine to the holy virgin—on the most prominent spot in the city. In response to his kind requests, there began a daily trading of praying people up the mud and rocks, seen while the foundation was being dug. This evident sign of faith helped to bring about the building of wooden steps in 1859, from the street below to the entrance of the church. The city built concrete steps in 1911, which, in 1958 [and 2009], were replaced by a more convenient structure. The placing of the large crucifix near the church entrance influenced more and more people to concentrate on Good Friday as "the day" for "praying the steps." The "Good Friday steps" are a symbol of hope to millions of devout souls.

Saint Lawrence Church

Saint Lawrence Church is located at 3680 Warsaw Avenue in the Price Hill neighborhood. The construction of the lower section of the Gothic building began in 1886, and the upper section was completed in 1894. Its spires are spectacular and are notable sights in Price Hill. According to a profile column, published by Cincinnati.com titled "Saint Lawrence, Price Hill's First Roman Catholic Church":

> There are two front towers and a third central one, the tallest of which reaches 189 feet into the sky. The towers are laced with arched stained-glass windows, interspersed with stone arches. Together, they create an awe-inspiring façade. The interior beauty of the church rivals that of the exterior. Interior plaster arches duplicate those outside. The windows above the main altar in the sanctuary were made using a medieval technique of blowing

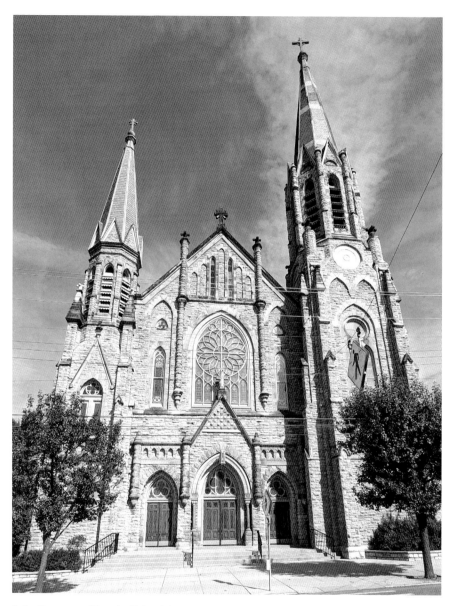

Saint Lawrence Church. *Robert Schrage.*

color into the glass by hand in Munich, Germany. Handcrafted works of art, created at great expense, these windows symbolized the sanctity of the space. Other windows in the church were made with a less expensive method of coloring glass by painting it with enamel by the Artistic Glass Painting Co. of Cincinnati.

While in Price Hill, a visit to the Holy Family Parish at 814 Hawthorne Avenue will not disappoint. On June 18, 1916, the Romanesque-style church was dedicated with services led by Cincinnati archbishop Henry Moeller. Also in Lower Price Hill is the old building of Saint Michael's, now a neighborhood community building. It was dedicated in 1848, and it is the second-oldest surviving Catholic church in Cincinnati. It is located on St. Michael Street.

CONCLUSION

This chapter has explored some of the architectural gems and historical sites of Cincinnati. However, very few sites so far are located in the Over-the-Rhine area of Cincinnati. It is time to visit Over-the-Rhine. While many of these structures have been lost over the years, many more remain. It is still one of the most intact historic districts in the United States.

5

OVER-THE-RHINE

R obert Wimberg, the author of what is perhaps the first guide to Over-the-Rhine in 1987, said it best: "A walk through the Over-the-Rhine neighborhood will take you through space, of course, but with a little imagination and knowledge, you can travel through time." There are many things that make Over-the-Rhine special, including the fact that it is one of the largest preserved historic districts in the country. There is so much to see, and the best way to see it all is to travel on foot with a little planning. There are not a lot of historical markers in the area, but this will not take away from the experience. There are numerous apps that can be utilized for walking the neighborhood. The most comprehensive Over-the-Rhine tour guide was written by Don Heinrich Tolzmann in 2011. Much has changed since 2011. However, many of the historic structures in the guide still exist. Some walking maps can be found on the internet, and there are private guided tour operators in the area. One recommendation would be to take a guided tour and then walk the neighborhood on your own afterward. Some tours will take customers to unique places they would not otherwise see.

To provide some background before exploring Over-the-Rhine, this chapter will provide a brief history of the neighborhood and some discussion on what the reader can expect to see.

A BRIEF HISTORY OF OVER-THE-RHINE

OTR, as it will now be called, is a neighborhood of Cincinnati that lies north of the Miami and Erie Canal (now the Central Parkway). The canal was referred to as the Rhine, in reference to the famous river in Germany. OTR was settled by German immigrants in the mid-nineteenth century and thrived with restaurants, theaters, singing halls and beer gardens.[42] The area was an interesting mix of both lively entertainment venues and places to live, worship and go to school. The neighborhood is made up of several areas, including the Washington Park Area, the Brewery District, the area north of Liberty and the area south of Liberty called Gateway Quarter and Pendleton.[43] However, this is a more modern division of the area within OTR. Historically, the neighborhood was divided differently. According to Robert Heuck, the entertainment district and the places people lived "cut the district in half and stretched on Vine Street from Doerr's on the canal up to Fifteenth Street, where Wielert's was located. This particular strip soon earned the name of 'the Broadway of the West' and Paris of America, while Cincinnati was called Porkopolis."[44]

The rich history of OTR starts with the large influx of German immigrants in the 1830s and 1840s. The immigrants settling in OTR did everything German—they spoke the language, ate German food, went to churches speaking the language, built German-style houses and read German newspapers.[45] According to Heuck in Tolzmann's *Over-the-Rhine Tour Guide*, "There were four German newspapers published in Cincinnati at the time, and there were German banks, German doctors, German lawyers, German merchants, whose clerks spoke German and understood the Germans' needs." A nice example of one of these OTR businesses is the Brighton German Bank on Central Parkway. While this bank is a little out of the way, it is a beautiful building situated on a picturesque corner.

Of the German newspapers, at least one of their buildings still stands. At the corner of Ninth and Vine Streets is the Cincinnati Freie Presse Company. The *Freie Press* was a weekly German newspaper founded in 1874. It ceased publication in the early 1960s. On the façade of the building in large letters is the name of the newspaper.

According to Tolzmann in *Over-the-Rhine Tour Guide*, the population in OTR reached seventy-five thousand at its "zenith" in the nineteenth century. It went back to about forty-five thousand in 1900. According to Cincy.com, in the 1950s, the OTR population was approximately forty-three thousand.

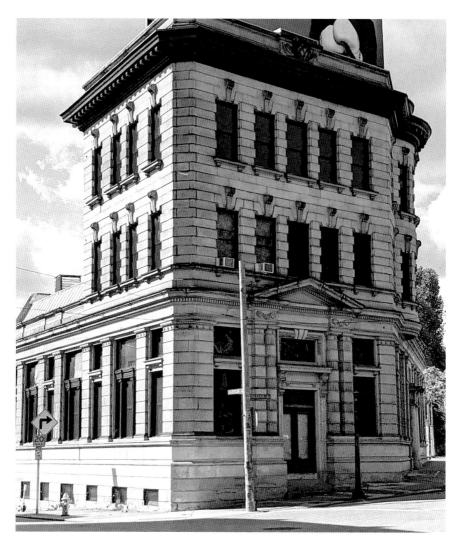

Brighton German Bank. *Ann Schrage.*

In 1940, there were eight breweries in Cincinnati and thirty-six by 1860. Brewers included George Herancourt, John Hauck, Christian Moerlein and Conrad Windisch. They became rich and were influential in the German community. Many beer barons can be found buried in Spring Grove Cemetery.

In the financial panic of 1857, many Cincinnati Germans entrusted their savings to the brewers rather than with the banks.…The brewing industry tended to concentrate along McMicken Avenue and the Miami and Erie

Canal (what is now the Brewery District). By 1866, the Jackson Brewery, J.G. John and Sons Brewery, Christian Moerlein Brewing Company and John Kauffman Brewing Company dominated the industrial use of the area. In close association on the west side of the canal were the John Hauck and Windisch-Mulhauser Brewing Companies. Between 1875 and 1900, fifteen breweries were located in Over-the-Rhine and West End.

Beer gardens of OTR, such as Henry Wielert's, were "quite popular." Today, the brewing district is alive and well, and individuals can visit a wide range of establishments and even take brewery tours focused on the industry's OTR history.

In 1855, Findlay Market opened and has been in continuous operation since. It is a must-see when visiting OTR. Cincinnati once had many public markets, but today, only Findlay Market remains. James Findlay was a general and veteran of the War of 1812 and Cincinnati's mayor on two separate occasions. He became a successful land merchant. He had a goal of establishing a public market but died before doing so. His heirs donated the land and named the new market for him. The Findlay Market Opening Day Parade marks the start of the baseball season and has been a community staple since 1920. If you are in town for opening day, the parade is worth seeing, as it captures so much of Cincinnati's traditions and history.

Cincy.com calls the period between 1860 and 1900 the "golden years" of OTR. This was the height of the neighborhood's significant cultural, economic and political influence. However, the most predictable aspect of OTR history is change. OTR has changed so much over the years.

Major changes occurred during World War I, Prohibition and World War II. Tolzmann calls it the "dark ages," as compared to the golden years. During the two World Wars, anti-German sentiment was loud and profound. The sentiment was felt so strongly that some streets were even renamed from German-sounding names to patriotic American ones. For example, Bremen Street was changed to Republic Street. Today, the old name appears on a building, while the new patriotic name adorns the modern street sign. This unique piece of history can be seen at Fifteenth and Republic Streets. This sentiment caused many German immigrants to move from OTR to more affluent neighborhoods, and then Prohibition hit.

Breweries that were very prevalent in OTR were forced to close.

By 1919, Prohibition had driven most of the breweries out of business. Christian Moerlein alone had employed over 500 people. Along with the World War I sentiments, this was the beginning of the decline of OTR's population and cultural homogeneity. Industry remained strong, and the

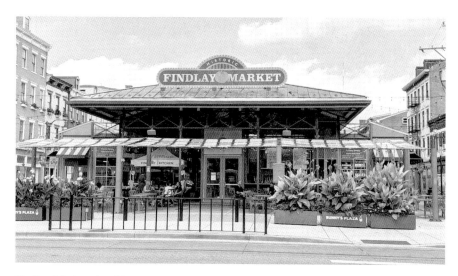

Findlay Market. *Ann Schrage*.

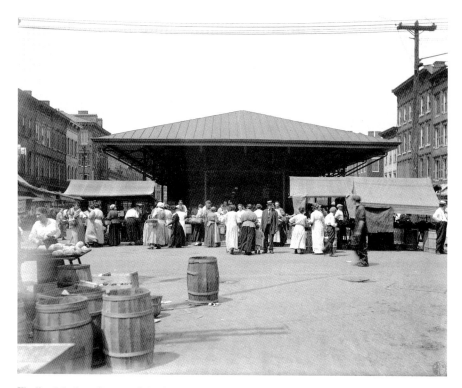

Findlay Market. *Courtesy of the Kenton County Public Library.*

Bremen Street, now Republic Street. *Kevin T. Kelly.*

area was still considered a working-class neighborhood. Many migrants from Appalachia and African Americans from the South moved in to become day laborers in the 1930s and '40s.

In 1928, the Central Parkway was built on top of the old canal that was not of much use anymore. The Miami and Erie Canal was constructed between 1825 and 1845. Railroads helped bring the demise of the canal, and by the late 1920s, it was dirty and unhealthy.

In later years, part of OTR was destroyed by construction of I-75 and I-71 on both the east and west sides. According to Cincinnati-Transit.net, "I-75 is the oldest, busiest, and most interesting expressway in the Cincinnati area. Its 22 years of construction on the Ohio side of the river stretched from 1941 to 1963, with the majority of the roadway built along the route of the old Miami-Erie Canal."[46] "The expressway required [the] demolition of dozens of city blocks and permanently altered the character of downtown and the West End—4,888 families (15,000–20,000 people) and 551 businesses were displaced."[47]

The Black population of OTR during the 1960s and 1970s grew significantly. According to Cincy.com, "Poor African American populations of those neighborhoods moved into OTR to live among the existing working-class Appalachians. Much of the historic housing stock was gutted at this

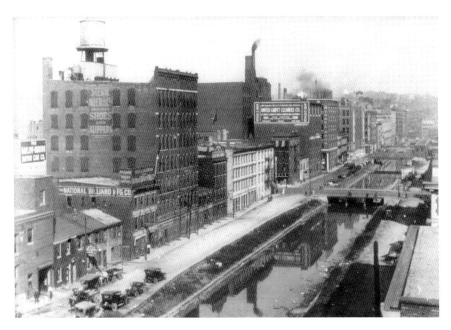

Miami and Erie Canal, Cincinnati. *From the collection of the Cincinnati and Hamilton County Public Library.*

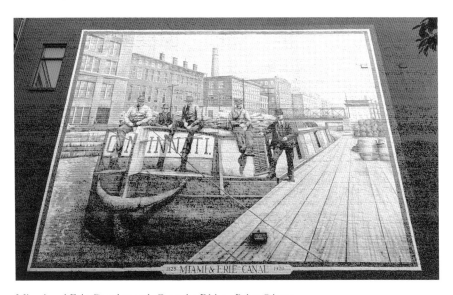

Miami and Erie Canal mural, Over the Rhine. *Robert Schrage.*

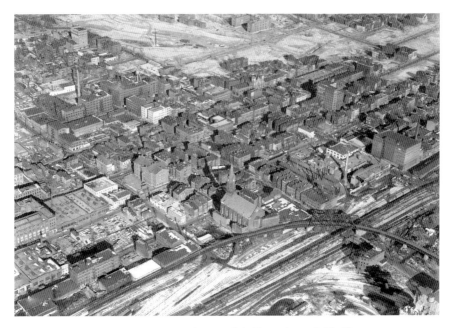

Demolition of the West Side for I-75. *Courtesy of the Kenton County Public Library.*

time in order to create affordable and efficient apartment dwellings for the residents. By the 1980s, crime and poverty were rising." Cincinnati became known as one of the most segregated communities in America. Difficulties resulted from this mixture of races and cultures. As the Black population of OTR rose, so did the rate of "white flight" to the suburbs. OTR became a predominately Black community.

OTR was added to the National Register of Historic Places in order to preserve the buildings in the neighborhood. This had some controversy, pitting preservationists against low-income housing advocates.

> *By 1990, Over-the-Rhine contained 2,500 government-subsidized low-income housing units (compared to virtually none in 1970) and had become one of the most economically distressed areas in the United States. The neighborhood had an extremely high poverty and unemployment rate, with the median household income of about $5,000 a year. An estimated 84 percent of its residents were classified as low income, and over 95 percent of all housing units were rentals.*[48]

Redevelopment eventually came to OTR, mostly through the efforts of the Cincinnati Center City Development Corp. (3CDC) and the municipal

government. The Cincinnati Art Academy moved to OTR, and the School for the Creative and Performing Arts was constructed by Washington Park. The Cincinnati streetcar travels to parts of OTR. While controversy was certainly evident due to arguments of gentrification and affordable housing concerns, there is little doubt these efforts have saved OTR from a continued deterioration and preserved this important neighborhood. These efforts continue, and OTR is a nice stop for lunch, dinner, artistic and historic exploration and entertainment. Like in any big city, it is important to be aware of your surroundings while walking around.

WHAT TO SEE IN OTR

Some important sites in OTR have already been discussed in this book, such as Washington Park, Music Hall, Memorial Hall and various churches. Additional must-see places include Findlay Market, Ensemble Theatre and revitalized breweries. Many tours of the neighborhood exist, including one related to food, general history, the Cincinnati underground and breweries. A quick online search will reveal numerous tour opportunities. One unique tour involves an exploration of the area's tenement life, and it rivals New York tours of a similar nature. There is so much to see and learn in OTR. On some apps, it is possible to create personalized walking tours. For the most part, it is suggested that visitors start at Music Hall and the Washington Park area, walk up to Twelfth Street and over to Vine Street and then head north. However, it is vital to get off this main path and visit the streets that

run north–south and east–west. Go as far east as Main Street and as far west as Central Parkway. Going north past Liberty Street will present you with the opportunity to view many beautiful buildings.

The architecture of OTR is mostly made up of ornate brick buildings that date from just after the Civil War to the 1880s. It is diverse and reflects the styles of the late nineteenth century.[49] This includes Queen Anne, Italianate, muted Greek Revival and simple vernacular styles.[50] Some of the most exciting discoveries in OTR are the ornamentations on the buildings. It is recommended to take a pair of binoculars with

Building art. *Robert Schrage.*

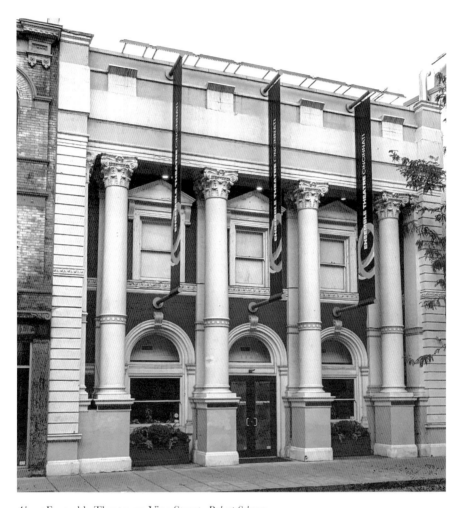

Above: Ensemble Theatre on Vine Street. *Robert Schrage.*

Opposite: Building art. *Robert Schrage.*

you when looking for any of these architectural gems in Cincinnati. In almost all cases, there will be some features on buildings that are best seen up close. They are often at the top of buildings or along the sides. They can be statues, masks, sculptures, animals or many other details. Sometimes it takes a hard look to find these gems, but the discoveries are very rewarding. Some other styles of architecture can be seen in OTR, such as Art Deco and Gothic, which provides for a nice mix. While exploring the neighborhood, find the ArtWorks mural titled *Over-The-Rhine: Into Its Renaissance*. According to ArtWorks, "This mural is inspired by the architectural details, landmarks and community spirit

found in Over-the-Rhine. Incorporated into the design are working hands, painting and planting, representing a growing and diverse community." It is located at 1519 Vine Street.

CONCLUSION

The vastness of OTR will become apparent very quickly. An explorer can spend several days on just OTR. This author walks the neighborhood often and still finds new discoveries. In Washington Park, children play, dogs bark and people relax; in other parts of the neighborhood, patrons visit the art venues and dine at the area's vast array of restaurants. You can even catch a major-league soccer game on the west side behind Music Hall. It is a vibrant and historic neighborhood. It is worthy of being called a "must-see" for the history lover.

ICONIC LOCATIONS AND MUSEUMS

T he purpose of this chapter is to visit iconic locations and museums that help tell the story of Cincinnati. The community is fortunate to have historic, compelling and beautiful locations and museums worthy of a visit. There is no better place to start than the most famous public space in town.

ICONIC LOCATIONS

Fountain Square

Fountain Square is the heart of Cincinnati. It is the center of the life of Cincinnati from a cultural, civic and commercial point of view. In the center of the square is the most recognizable landmark in Cincinnati, the Tyler Davidson Fountain. Fountain Square was not always so beautiful, as the area once served as a butcher's market. In developing the square, the butchers refused to leave, and the city sent in workers to tear down their stalls.[51]

For 130 years, the Tyler Davidson Fountain was located in the middle of Fifth Street and west of Walnut Street. Today, it rests on the iconic square and stands forty-three feet tall. It is cast in bronze and rests on a green granite

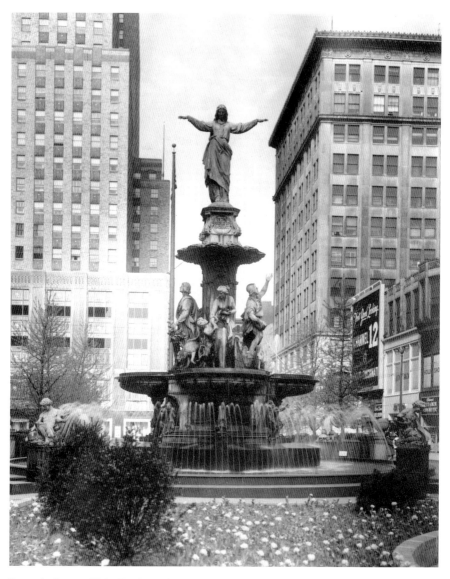

Fountain Square (Tyler Davidson fountain in 1954). *Courtesy of the Kenton County Public Library.*

base. It was constructed in 1871. The following is a detailed description of the fountain:

> *The artistic fountain's motif is water, in homage to the river city's continuing debt to the Ohio River. The central figure, the Genius of Water—a female in heroic size—pours down the symbolic longed-for rain from hundreds of jets pierced in her outstretched fingers. The figure is 9 feet high and weighs 2 tons. The pedestal itself is square, with four representations in basso-relievo of four principal uses of water, namely steam, water power, navigation and the fisheries. The first is typified by workers in iron using a trip hammer powered by an engine in the background; the second by peasants carrying corn to a watermill; the third by a steamboat leaving the shore, lined by numbers waving farewell; the fourth by groups of fishermen and children. From the center of the pedestal rises a shaft spread at the top with interlaced vines and foliage and about these are four groups. On the north is a workman standing upon a burning roof and imploring the aid of water; at the south is a farmer standing in the midst of a field where are plainly seen the effects of a drought—he, too, is praying for rain. Upon these two groups the Genius of Water is dropping a gentle spray. At the west a young girl is offering the water to an old man with crutches. On the east side, a mother, partially nude, is leading her naked and reluctant boy to the bath. Four outer figures with animals represent the pleasures of water. These are working drinking fountains from which passersby can drink. On the drinking fountains are figures of nude boys—one riding a dolphin, another playing with ducks, a third struggling with a snake and the fourth on the back of a turtle.[52]*

The fountain was purchased in Munich, Germany, by Henry Probasco and brought to Cincinnati as a memorial to his brother-in-law Tyler Davidson. An original miniature model of the fountain can be seen at the Cincinnati Art Museum.

The square, as it is seen today, is the result of a major renovation in the early 2000s, including a restoration of the fountain and the movement to its current location. Fountain Square hosts many events throughout the year and is a place where people gather to eat, relax, rally and converse.

ArtWorks Murals

ArtWorks is a nonprofit organization that has transformed Cincinnati's reputation to be that of an arts community and destination. The nonprofit has created public murals that can be seen all around the region. They depict beautiful works of art, many centered on the history of Cincinnati as a city and its people. Mural tours and additional information can be found on the ArtWorks web page. Two of this author's favorite murals include tributes to Cincinnati boxer Ezzard Charles (the Cincinnati Cobra) and Neil Armstrong, the first man on the moon. Charles was a World Heavyweight Champion. Armstrong taught at the University of Cincinnati and lived in the region. A tour of all the beautiful murals will provide both a rewarding artistic adventure and a nice review of fascinating Cincinnati history.

Top: Ezzard Charles mural. *Kevin T. Kelly*.

Bottom: Neil Armstrong mural. *Kevin T. Kelly*.

Coney Island

Today, Coney Island in Cincinnati is the place to swim. It is home to the largest recirculating swimming pool in the world. However, the history of the site is one of complete joy. The pool itself dates to 1925. The larger site was home to one of Cincinnati's amusement parks, where generations of people enjoyed its rides and carnival games until it closed after the 1971 season. From the old amusement park, the 1925 Moonlite Gardens Dance Pavilion still stands. The gates to the car entrance at 6201 Kellogg Avenue and the historic boat/public landing on the Ohio River also still stand. Boats, including the historic *Island Queen*, dropped off generations of people here to enjoy a day at Coney Island. Riverbend Music Center is now located at Coney Island and is one of Cincinnati's most used venues. Also, Belterra Park, formally known as River Downs, is located next to Coney Island. It was originally named Coney Island Racetrack when it opened in 1925. However, it was destroyed by the 1937 flood and was rebuilt and renamed River Downs.

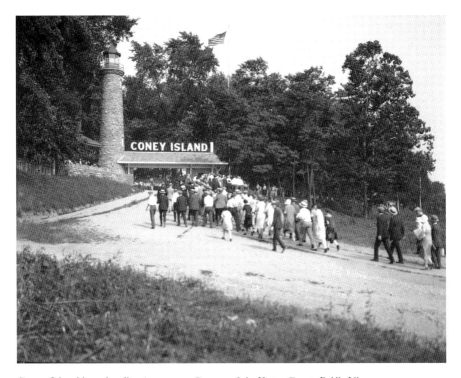

Coney Island boat landing/entrance. *Courtesy of the Kenton County Public Library.*

109

Lunken Municipal Airport

If you are interested in aviation history, Cincinnati's Lunken Municipal Airport is a nice stop. It is located on Wilmer Avenue, a few miles out of downtown. Until 1947, it was Cincinnati's main airport. "It is in the Little Miami River Valley near Columbia, the site of the first Cincinnati-area settlement in 1788. When the 1,000-acre airfield opened in 1925, it was the largest municipal airfield in the world. The airport was named for Eshelby Lunken, whose father, Edmund H. Lunken, ran the Lunkenheimer Valve Company. (The family's last name had been shortened from its original 'Lunkenheimer' spelling.)"[53] The old control tower is the oldest standing control tower in the United States.[54] The terminal building dates to 1937. In 1927, Charles Lindbergh and the *Spirit of St. Louis* landed at Lunken to a large and enthusiastic crowd. In 1930, a formal dedication was held, and the dignitaries present included Howard Hughes and Jimmy Doolittle.

Anderson Ferry

Located west of downtown is the Anderson Ferry, and it has been in operation since 1817. It is listed in the National Register of Historic Places and docks in Cincinnati and in Hebron, Kentucky. According to its website, "The first ferry was made of wood, and the paddlewheels turned as horses walked along a treadmill."

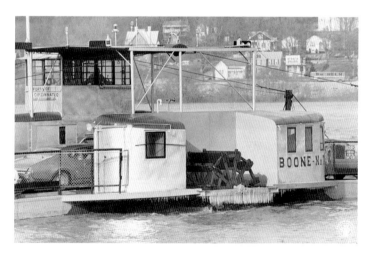

Anderson Ferry/Boone No. 7. *Courtesy of the Kenton County Public Library.*

Arnold's Bar and Grill and O'Malley's in the Alley

The oldest bar in Cincinnati is Arnold's, located at 210 East Eighth Street downtown. According to its website: "The two buildings that make up Arnold's Bar and Grill were built in the late 1830s. The bar room at 210 East 8th Street was originally a barbershop, and the other building, 208, first housed a feed store, with the adjacent courtyard used for a stable and carriage

house. Simon Arnold opened his tavern in 1861 in the same room that continues as the oldest bar in the city of Cincinnati."

O'Malley's in the Alley champions itself as Cincinnati's "second-oldest bar." It is also located downtown in an alley at 25 Ogden Place. It has been in this location since 1892. Off the main roads, it is a special place. Both Arnold's and O'Malley's are the perfect places to stop for a break while exploring downtown.

Left: O'Malley's in the Alley. *Robert Schrage.*

Below: Arnold's Bar and Grill. *Ann Schrage.*

Krohn Conservatory

Located in Eden Park, the current Krohn Conservatory building has been in operation since its opening in 1933 on land owned by Nicholas Longworth. Longworth called the land his Garden of Eden. The building has Art Deco features and was named after long-serving park board member Irwin M. Krohn. It includes a fern house, palm house, desert home, bonsai gallery and special exhibits. In the spring is the popular butterfly show. Christmastime is an especially perfect time to visit the conservatory. Its displays include many decorations; model trains with landscapes of Cincinnati's top historic attractions, such as Roebling Suspension Bridge, Union Terminal, former inclines and Elsinore Arch; and a nativity scene. The display of a nativity during the holidays is a long-standing tradition. It was displayed downtown in Lytle Park starting in 1939 and was moved to the conservatory in 1967.

Eden Park Overlook

After visiting the conservatory, proceed east on Eden Park Drive to visit the Eden Park Overlook. It is located on the right, just after you go under the Cliff Drive Bridge. Turn onto Lake Drive. The overlook is in the Twin Lakes area and is mentioned because it provides one of the most beautiful views from high above the Ohio River. When looking down at the river, it is easy to envision why and how it influenced the settlement of Cincinnati. For an even higher vantage point, take St. Paul Drive across the street, and then turn left on Alpine Place to Cliff Drive. Find the Ohio River Monument at the Donald Spencer Overlook.

The Steps of Cincinnati

Cincinnati is home to many beautiful and historic sets of steps. In fact, according to the City of Cincinnati, there are nearly four hundred sets of steps in the city. One of this author's favorite guides was written by the late Mary Anna DuSablon and is titled *Walking the Steps of Cincinnati*. The original book was updated in 2014 by John Cicmanec and Connie J. Harrell. Following this guide and walking the historic steps is an excellent way to see the many neighborhoods of Cincinnati. Early on, people had to get from the hills of Cincinnati to the flat downtown, which involved

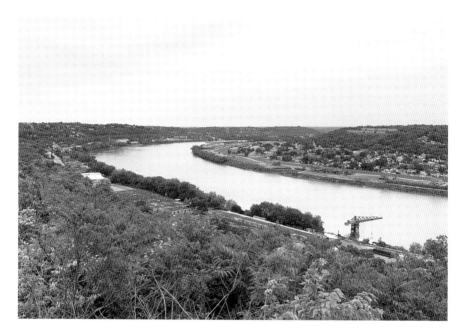

Above: Eden Park Overlook.
Kevin T. Kelly.

Left: Entrance to Mount
Adams Steps. *Robert Schrage*.

steps. Later, inclines made it easier, but the steps even served the inclines. So many of these historic steps still exist. As Harrell said in the preface to the 2014 edition of DuSablon's guide: "Each walking tour proved to be a living history lesson about the people and events in its neighborhood." By walking the steps, DuSablon said, "I wanted to learn more about Cincinnati's history. Buildings, steps and sidewalks that previously had passed by unnoticed in a car suddenly took on significance."

The Gazebo at Eden Park

The Spring House Gazebo in Eden Park was completed in 1904 and takes its name from the old spring house it replaced. The spring water was believed to have therapeutic qualities. However, it was found to be contaminated and was sealed off in 1912.[55] The gazebo sits at Mirror Lake, which is a reflecting pool and former city reservoir. In 1878, the city built a large reservoir that sat on twelve acres and held ninety-six million gallons of water.[56] Remnants of the old reservoir still exist today, and a walk through the area will reveal some pieces of history.

The Eden Park gazebo in the blizzard of 1978. *Courtesy of the Kenton County Public Library.*

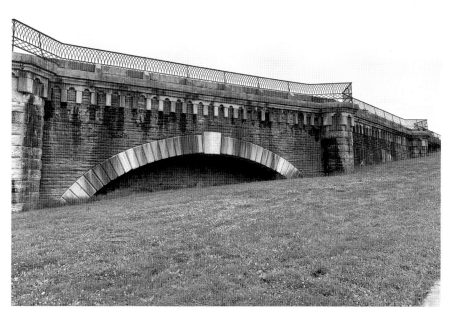

Reservoir remnants. *Kevin T. Kelly.*

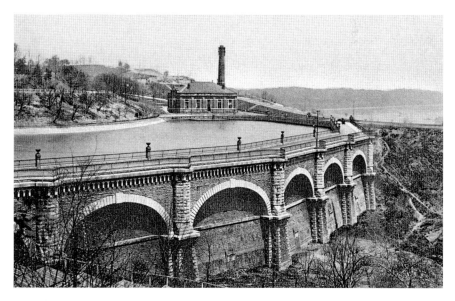

Eden Park Reservoir. *From the collection of the Cincinnati and Hamilton County Public Library.*

A History Lover's Guide to Cincinnati

One of the most famous incidents at the gazebo occurred on October 6, 1927. George Remus was a famous bootlegger who spent two years in a federal prison. There, he met Franklin Dodge, an undercover Prohibition agent. Eventually, Dodge would have an affair with Remus's wife. "The pair liquidated Remus's assets and hid as much of the money as possible in addition to attempting to deport Remus and even hiring a hit man to murder Remus for $15,000."[57] Remus's wife, Imogene, filed for divorce in 1927. According to author Jeff Morris, "On the way to court on October 6, 1927, for the finalization of the divorce, Remus had his driver chase the cab carrying Imogene and her daughter through Eden Park in Cincinnati, finally forcing it off the road. Remus jumped out and fatally shot Imogene in the abdomen in front of the Spring House Gazebo."[58] Remus was found innocent after arguing an insanity defense. Rumor has it the gazebo is haunted by the ghost of Imogene.

Albee Theater Façade

The Albee was one of the most loved and beautiful theaters in Cincinnati and dated to 1927. It was demolished in 1977 in order to make room for the Westin Hotel on Fifth Street. The front of the theater had an outstanding marble arch that was saved. Today, it has been incorporated into the south side of the Cincinnati Convention Center on Fifth Street.

Spring Grove Cemetery and Arboretum

A national landmark, Spring Grove Cemetery and Arboretum comprises 750 acres of trees and fifteen lakes. It is a terrific place to hike and explore history. It is one of only five cemeteries in the nation that holds a national historic landmark designation. It is also in the National Register of Historic Places. It was established in 1845, with the first burial taking place that same year. Salmon P. Chase and others prepared the articles of incorporation. Chase was buried on a hill that overlooks a lake in Spring Grove.

If you are visiting, stop by the cemetery office first, as it contains a wealth of information, including maps, descriptions and walking guides. The cemetery staff is very friendly and have a strong focus on customer service. Many Cincinnati notables are buried in Spring Grove, and it is interesting to learn about these people and then visit their final resting places. Many beer

116

Left: Albee Arch at the Cincinnati Convention Center. *Robert Schrage.*

Below: Dexter Mausoleum. *From the collection of the Cincinnati and Hamilton County Public Library.*

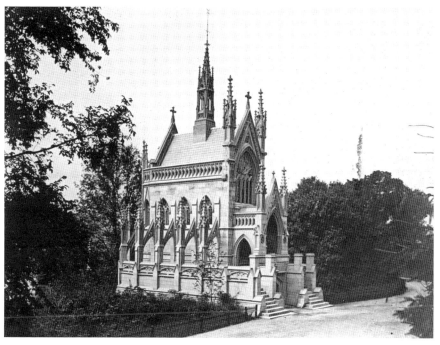

barons, sports figures, politicians, Civil War figures and business leaders were buried here. After reading this guide and other Cincinnati history sources, names such as Longworth, Crosley, Taft, Kroger, Hannaford, Procter, Gamble, Hoyt, Fleischman, Chase, Cox, Hooker, Probasco, Davidson, Muhlhauser, Moerlein and Carew will be familiar—and they were all buried at Spring Grove.

In addition to all this, Spring Grove includes many historic structures, some of which have been discussed previously. No visit would be complete without visiting the Gothic Revival Dexter Mausoleum. Other must-sees include the gatehouse, chapels and Soldiers Monument.

Cincinnati Zoo and Botanical Garden

Founded in 1873, the Cincinnati Zoo is the second-oldest zoo in the United States. It opened officially in 1875. An animal park was first proposed in 1868, and the local zoological society began raising funds for its construction. Andrew Erkenbrecher retired from his starch manufacturing business to start the zoo.[59] Around 1,200 people attended opening day on September 18, 1875. The grounds were unfinished, and its animals included "a talking crow, an unenthusiastic lioness, a few monkeys, some deer and birds and Conqueror, an elephant purchased from a circus."[60]

A memorial to Martha, the zoo's last passenger pigeon who died at the Cincinnati Zoo in 1914, can be visited. Some of the site's historic structures still exist but not many. One notable exception is the reptile house, which was built in 1875; it is the oldest existing zoo building in America.

Ezzard Charles Statue

Dedicated in 2022, the Ezzard Charles statue is located in Ezzard Charles Park on the west side of downtown. One part of the statue quotes Charles: "Don't lead with your chin, but keep looking up." Charles was born into poverty in Lawrenceville, Georgia, on July 7, 1921—the Jim Crow South. A sign in the park reads, "Charles overcame adversity throughout his life, leaving a legacy of honor, dignity, respect and generosity that still thrives to this day." The former heavyweight champion died of amyotrophic lateral sclerosis (ALS) in 1975 in Chicago. Rocky Marciano called Charles "the bravest man he ever fought."

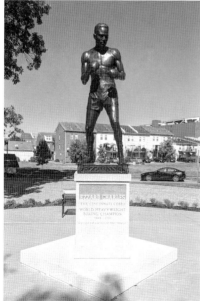

Above: Cincinnati Zoo reptile house. *Robert Schrage*.

Left: Ezzard Charles statue. *Robert Schrage*.

University of Cincinnati

The University of Cincinnati was founded in 1819. Its origins date to the founding of the Medical College of Ohio and Cincinnati College, which was founded by Daniel Drake. In 1870, the City of Cincinnati established the university and "absorbed" the previous institutions. It is one of the most architecturally diverse campuses in the United States and contains some historic buildings. As previously discussed, Nippert Stadium has been used since 1901, and many of its buildings date to the early twentieth century. Examples include the College of Law building (1925), Arts and Sciences Hall (1950), Blegen Library (1930) and Memorial Hall (1924). The armory fieldhouse still stands where, for twenty-two years, it was the home of the men's basketball games, including the 1961 and 1962 seasons, when the Bearcats won back to back NCAA titles. It was the "homecourt for Bearcats greats Oscar Robertson and Cheryl Cook, as well as UC's two National Championship teams."[61]

The Parks System

Cincinnati and Hamilton County are very fortunate to have beautiful and well-run park systems. It would be short-sighted to not mention them in this guide, as they provide excellent opportunities for recreation and exploring. Great Parks of Hamilton County, the name of the Park District, was established in 1930 and the first park was named Sharon Woods and opened in 1932. There are twenty-two parks and preserves in the system.

The Cincinnati Park system dates to the creation of a board of park commissioners in 1906, and the foundation of the park system was laid out in a master plan the next year. It was written by German-born architect George Kessler. According to the City of Cincinnati's online history of the parks: "By the early 1920s, most of the parks recommended that the 1907 plan had been established through an aggressive campaign of land acquisitions. From 1907 through 1925, 70 parks, playgrounds and squares had been established, some with the help of major donations. Landmark parks that came about soon after the Kessler Plan included Mt. Airy Forest, Ault Park and Mt. Storm Park." Today, Cincinnati Parks covers more than five thousand acres. Cincinnati had historically been proactive in park development prior to the creation of the park board. For example, in 1860, Washington Park was created, and Eden Park land acquisition began in 1859.

MUSEUMS

Cincinnati is very fortunate to have many excellent museums, including those that tell the history of the city itself. Like in any large city, there are a wide range of museum opportunities in Cincinnati. The following section is not meant to be all-inclusive, but it certainly does include a wide range of excellent museums that cover a broad range of historical topics.

Cincinnati Museum Center

The Cincinnati Museum Center is located at Union Terminal. The building is one of the most significant in Cincinnati and is another must-see. It opened in 1933 as a train terminal, greeting thousands of families as they bid both welcome and farewell to their loved ones. In fact, Union Terminal was the main point of transfer for homeward-bound western soldiers following World War II. It is considered one of the last great railway stations built in the United States. The rotunda's interior dome spans 180 feet and is 106 feet tall. According to the museum center's web page, the building was designed to accommodate 17,000 passengers and 216 trains a day. Service by passenger trains stopped in 1972, but Amtrak began operating out of the building in 1991. An excerpt from the museum center's web page describes the experience of visiting the terminal well:

> *After you pick your jaw up off the floor from admiring the largest half-dome in the western hemisphere, ask a member of guest services about the magical whispering fountains. Spend some time admiring the intricate details and stories of the Winold Reiss mosaics and visit Tower A, the original control tower of Union Terminal. Be sure to pick up a sweet treat in the Rookwood-tiled ice cream parlor before heading outside to enjoy it next to the fountain with a unique view of downtown Cincinnati.*

Today, the Art Deco building houses the Cincinnati Museum of Natural History and Science, the Children's Museum, the Cincinnati History Museum and the Nancy and David Wolf Holocaust and Humanity Center. Also, Union Terminal is home to the Cincinnati History Library and Archives. For the purposes of this guide and the history of Cincinnati, the Cincinnati History Museum will provide a great experience for those who wish to explore Cincinnati's history from settlement to modern times.

Included in the Cincinnati History Museum is a re-creation of the public landing from the late 1850s and the *Queen of the West*, a replica sidewheel steamboat. A favorite of this author is the 1/64 scale replica of Cincinnati and, according to the museum web page: The "nation's largest S-scale train model." Exploring the museum is a great way to start or end your historical adventures around Cincinnati.

The Museum of Natural History and Science is Cincinnati's oldest museum, having been founded in 1818 by physician and scientist Dr. Daniel Drake. According to author Rick Pender in his book *Oldest Cincinnati*, Drake hired John James Audubon (1785–1851), a Frenchman who immigrated to the United States in 1803, as the museum's first paid employee. Drake encouraged Audubon to compile his legendary color-plate book of illustrations, *The Birds of America*, which was published in sections from 1827 to 1838.

American Sign Museum

The American Sign Museum is dedicated to "the art and history of commercial signs and sign making." According to its web page, "The American Sign Museum is proud to be the largest public museum dedicated to signs in the United States! Covering more than 100 years of American sign history in 20,000 square feet of indoor space, the museum is a walk through the ages of technology and design." It is located at 1330 Monmouth Avenue in Camp Washington.

National Underground Railroad Freedom Center

The National Underground Railroad Freedom Center was discussed briefly in chapter 1 of this book. The concept of this project was first proposed in 1994, and fourteen thousand people attended its ground breaking in 2002. It opened in 2004. The center provides many thought-provoking exhibits and programs, online resources and a family search center.

Cincinnati Fire Museum

The Cincinnati Fire Museum is focused on the city's fire history and the many contributions the city has made to the profession of firefighting. It is a joint

effort of the museum and the Cincinnati Fire Department. Cincinnati had the first paid professional fire department in the nation, which was founded in 1853. The museum is located in a historic firehouse that, in 1906, was the city's busiest. Located at 315 West Court Street, the museum features artifacts such as leather fire buckets, volunteer-era parade helmets, the 1808 fire alarm drum, the 1816 Hunneman fire engine, the *Aurora* (an 1884 Ahrens fox steam fire engine), Cincinnati Fire Department engine 13 (a 1917 Ahrens fox piston pumper) and the 1958 northern hills fire engine, the last Ahrens fox pumper produced.

Cincinnati Fire Museum/Historic Firehouse. *Robert Schrage*.

Greater Cincinnati Police Museum

The Greater Cincinnati Police Museum is located at 308 Reading Road, and its vision is to become "the area's principal, if not only, regional repository for related artifacts, records, and research resources of law enforcement." It states, "The Greater Cincinnati Police Museum is the only regional police museum in the country. We cover all federal, state, local, and private agencies in southwest Ohio, northern Kentucky and eastern Indiana, the safest place in the country to live." Visiting hours are limited, so check its web page before going.

Skirball Museum

The Skirball Museum is located at 3101 Clifton Avenue and is one of the oldest depositories of Jewish cultural artifacts in the United States. Dating to the opening of Hebrew Union College in 1875, it has collected items of tremendous historical significance. According to the museum's history on its web page: "In 2015, B'nai B'rith International and HUC-JIR announced the transfer of the art and artifacts of the former B'nai B'rith Klutznick National Jewish Museum for the purposes of preserving

and displaying this distinctive collection of sacred and secular fine and decorative arts. The B'nai B'rith Klutznick collection augments and enhances the Skirball's holdings significantly, rendering it among the most prominent Jewish museums." This museum is amazing and will never disappoint. Its artifacts and stories are as impressive.

Betts House

The Betts house was built in 1804 and is the oldest brick home in Ohio and the oldest remaining residential structure in downtown Cincinnati.[62] It is located at 416 Clark Street in the Betts-Longworth neighborhood. It is open to the public and owned by the National Society of Colonial Dames of America in the State of Ohio. The home's original owners were William and Phebe Betts, who traveled west from New Jersey, looking for a better life. Upon arriving in Cincinnati, William obtained 111 acres as a debt repayment. He constructed the federal period house, and "over the following decades, four generations of Betts family members called the Betts house home and raised over two dozen children within its walls."[63]

Lloyd Library

[Located at 917 Plum Street,] *the Lloyd Library and Museum is a world-renowned independent research library and exhibit space devoted to bringing science, art and history to life. Considered one of Cincinnati's treasures, the Lloyd Library and Museum was established by three brothers, John Uri, Nelson Ashley and Curtis Gates Lloyd, pharmacists who manufactured botanical drugs in Cincinnati beginning in the late 19th century. The library holds, acquires, preserves and provides access to both historic and current books and journals, as well as archival materials on a wide variety of disciplines, including botany, pharmacy, natural history, medicine, scientific history and visual arts.*[64]

The library is privately funded and open free of charge to the public.

Cincinnati Reds Hall of Fame and Museum

The Cincinnati Reds Hall of Fame and Museum is located at Great American Ballpark and is an excellent place to explore the history of the city's first professional baseball team. The hall of fame began in 1958 to honor players, managers and executives. The museum opened in 2004 and will be discussed further in an upcoming chapter on Cincinnati's professional sports.

William Howard Taft Boyhood Home

The boyhood home and birthplace of President William Howard Taft is located at 2038 Auburn Avenue. He is the only individual to serve as both president and chief justice of the supreme court. More on Taft and the home will be discussed in the chapter on the history of the presidency in Cincinnati.

Harriet Beecher Stowe Home

As mentioned in chapter 1 of this book, the Harriet Beecher Stowe house is located at 2950 Gilbert Avenue and provides an opportunity to learn about the author and abolitionist and her novel *Uncle Tom's Cabin*. Visiting hours vary, and topics discussed include her family, the Lane Seminary debates, the Underground Railroad and the recent history of the house.

The Art Museums of Cincinnati

The Cincinnati art museums discussed here include the Cincinnati Art Museum, the Taft Museum of Art, the Contemporary Arts Center, the 21C Museum Hotel and the Weston Art Gallery.

The Cincinnati Art Museum, located in Eden Park, is one of the best in the country. The museum can trace its roots back to the creation of the Women's Art Museum Association in 1877. The group's goal was to "promote the benefits such an institution would provide for the community."[65] The Cincinnati Art Museum (originally at Music Hall) was incorporated in 1881, and the current Eden Park building opened in 1886. It was decided

to put the museum in Eden Park because it was "conveniently located near downtown Cincinnati but high enough to escape the worst of its industrial pollution."[66] James W. McLaughlin designed and oversaw the original building's construction. At the site, the Art Academy of Cincinnati opened in 1887, the Schmidlapp Wing opened in 1907 and the Ropes Wing opened in 1910. Other wings followed. In 2020, the new Art Climb was constructed, better tying the museum into the nearby community and park. The Art Academy moved to a location downtown, and its former building is now part of the museum. The art museum has an impressive and famous permanent collection and offers special exhibits. At the museum's entrance is a twelve-foot-tall bronze statue of Pinocchio. Admission to the museum is free.

The Taft Museum of Art's building will be discussed in the chapter on Cincinnati's presidential history. It is located at 316 Pike Street downtown, and admission is free on Sundays. Its diverse collections are described well on its web page: "Our 200-year-old house holds a remarkable collection that spans the Middle Ages through the 19th century, with European and American paintings, and 18th-century watches, Chinese porcelains and French Renaissance enamels. The collection features iconic artists, including Rembrandt, Goya, Gainsborough, Turner, Ingres, Whistler and Sargent, as well as federal-period American furniture and the most significant pre–Civil War domestic murals in the United States." In addition to the museum's tremendous art collection are its murals of Robert S. Duncanson. Duncanson, according to the historical marker outside the museum, was "the first African American artist to achieve international acclaim." Duncanson was commissioned by Nicholas Longworth to paint these murals in his home, today's Taft Museum. These pre–Civil War murals are outstanding pieces of history and alone are worth a trip to the museum.

The Contemporary Arts Center is located at 44 East Sixth Street downtown. Founded in 1939, it is said to be one of the first contemporary art institutions in the United States. The current building was designed by famed architect Zaha Hadid—her first in America. It opened in 2003 and was the first American museum designed by a woman.[67] The museum offers a wide range of exhibits, programs and events. The building is named the Lois and Richard Rosenthal Center for Contemporary Art.[68]

Cincinnati is also home to many art galleries that display the works of local, regional and national artists. A quick internet search will help you find these galleries.

The 21C Museum Hotel is located at 609 Walnut Street, next to the Contemporary Arts Center. While it is a hotel, the public is welcome to

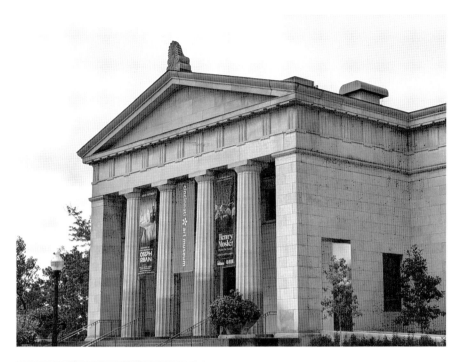

Above: Cincinnati Art Museum. *Robert Schrage*.

Left: Contemporary Arts Center. *Kevin T. Kelly*.

visit this beautiful and historic building and its collection of contemporary art. The building itself is historic and was formally the Hotel Metropole, designed by Joseph and Bernard Steinkamp. Another arts stop is the Weston Art Gallery, located in downtown Cincinnati at the Aronoff Center. It supports and displays works by local and regional artists.

Price Hill Historical Society & Museum

The Price Hill Historical Society and Museum is located at 3640 Warsaw Avenue and has regular but limited hours. Check its web page for further information on hours or to make an appointment. The museum is located in an old Art Deco bank building. The museum comprises two floors of memorabilia, artifacts and a library. There is much to explore and learn about this historic neighborhood of Cincinnati. In a description titled "Price Hill: A Brief History," which was written by the historical society:

> *Price Hill was once praised as Cincinnati's most popular and distinctive suburb. It was a neighborhood where one could escape the smells of the city and enjoy the comforts, peace and prosperity of living in a hilltop resort community. To this day, many descendants of those early residents live, worship, work and play on that same western hill, Price's Hill. In 1791, William Terry built*

Price Hill Historic Society Museum. *Robert Schrage.*

Skyline Chili Booth, Price Hill Historic Society Museum. *Robert Schrage.*

his log cabin in the midst of a virgin forest that was home to the local Indian tribes. This was probably the first home on Bold Face Hill, named for Chief Bold Face, and the original name of Price Hill.

As a lover of Cincinnati food, this author liked seeing there a booth from the original Skyline Chili, built by the Nicholas Lambrinides family in Price Hill in 1949. The museum is staffed by dedicated volunteers and is highly recommend for a visit.

Delhi Historical Society Farmhouse Museum

The Delhi Historical Society Farmhouse Museum is located at 468 Anderson Ferry Road, and admission is free. Visiting hours are limited, so check its website or call before going. This historical society was founded in 1976, and its mission "is to serve as a steward of local history, telling the stories of the people who lived and worked here. It does so by collecting, preserving and exhibiting materials that document the history of the township and its surrounding area; by educational programs for children and adults; and by maintaining the 1870s Witterstaetter Farmhouse Museum, library, research center and historic greenhouse."[69]

Laurel Court: The Home of Peter G. Thomson

Laurel Court was built between 1902 and 1907 and was home to Peter G. Thomson, the founder of Champion Paper. It is a two-story home, contains thirty-six rooms and comprises twenty thousand square feet.

> *The home features a grand staircase imported from Europe, inlaid marble floors and a music room finished in gold leaf. The dining room is adorned with sterling silver light fixtures and ornately carved trim. The library is paneled in rare African rosewood, and the billiard room is paneled with figured African mahogany. In the center of the home is an atrium with a removable glass dome. Complementing the property are French Château–style cottages, a French country-style carriage house and expansive gardens. The grounds include a formal French garden with marble statuary and carved stone balustrades, perennial gardens, a Japanese garden with koi ponds and a pool that lies just beyond a wisteria-covered pergola. At the edge of the Laurel Court property, Peter Thomson built a lovely house for his daughter Mary Bell and her husband, Walter Randall.*[70]

Laurel Court is privately owned but is available for tours and private events. It is an amazing setting for weddings, reunions, business meetings and many other events.

Designed by architect James Gamble Rogers, it is one of the best surviving examples of buildings from the Gilded Age. It is located at 5870 Belmont Avenue.

Cincinnati Type and Print Museum

Located in Lower Price Hill, the Cincinnati Type and Print Museum is at 2307 West Eighth Street in the former William Hillenbrand Company building. The museum was founded by Gary Walton. In an article written by Tom Connor in the Price Hill Historic Society newsletter, *Heritage on the Hill*, in October 2022, "In 2021, Gary teamed up with BLOC Ministries to develop the idea of a job training center using historic printing equipment." This became the museum, and it has a large collection of presses and other printing equipment, the oldest being from the 1800s. Visitors are welcome, and the museum's contact information can be found on its web page.

CONCLUSION

These locations have plenty to offer. Everyone has different interests, and Cincinnati offers many unique opportunities to explore. The places identified in this chapter will provide rewarding glimpses into Cincinnati's history and current cultural scene.

7

THE NEIGHBORHOODS OF CINCINNATI

The city of Cincinnati is made up of fifty-two distinct neighborhoods, each with their own unique history. It is possible to find other sources that put the neighborhoods at a higher number, but officially, it is fifty-two. Many of the neighborhoods were at one point separate jurisdictions that have since been annexed by the City of Cincinnati. These suburbs have been called "its crowning glory."[71] At first, it seemed unlikely the city would expand from the river basin to the steep hills surrounding downtown. However, people moved to the hills and beyond, in part to escape pollution. The beauty of the valley became apparent when looking down at the Ohio River. People were "awakened to the fact that the high hills and deep ravines that surround Cincinnati are to become its most attractive feature."[72] These words, written in 1870, were an accurate description of what was to be. People moved, churches were built, businesses were started, transportation modes developed and neighborhoods were created.

According to the web page Cincinnati History, Greater Cincinnati's Past and Present:

Motivated by what seemed like mediocre population growth after the war, the city's leadership began to push for expansion, as Chicago's population surpassed it in the late 1860's. Already smaller than St. Louis, Cincinnati's leadership feared a loss in prestige and relevance, as other Midwestern cities like Cleveland and Detroit exploded in size. By 1870, Cincinnati's leaders were calling for "annexation of all outlying villages at once, stressing

Sayler Park mural. *Ann Schrage.*

the inefficiency of having 11 mayors within a seven mile radius of the [Hamilton] *county courthouse." Hence began an annexation spree that continued well into the 20th century, growing Cincinnati to 80 square miles.*

LISTING OF THE NEIGHBORHOODS

The following is a listing of the neighborhoods of Cincinnati:

Avondale, Bond Hill, California, Camp Washington, Carthage, Clifton, College Hill, Columbia Tusculum, Corryville, CUF, Downtown, East End, East Price Hill, East Walnut Hills, East Westwood, English Woods, Evanston, Hartwell, The Heights, Hyde Park, Kennedy Heights, Linwood, Lower Price Hill, Madisonville, Millvale, Mount Adams, Mount Airy, Mount Auburn, Mount Lookout, Mount Washington, North Avondale, North Fairmount, Northside, Oakley, Over-the-Rhine, Paddock Hills, Pendleton, Pleasant Ridge, Queensgate, Riverside, Roselawn, Sayler Park, Sedamsville, South Cumminsville, South Fairmount, Spring Grove Village, Villages of Roll Hill, Walnut Hills, West End, West Price Hill, Westwood and Winton Hills.

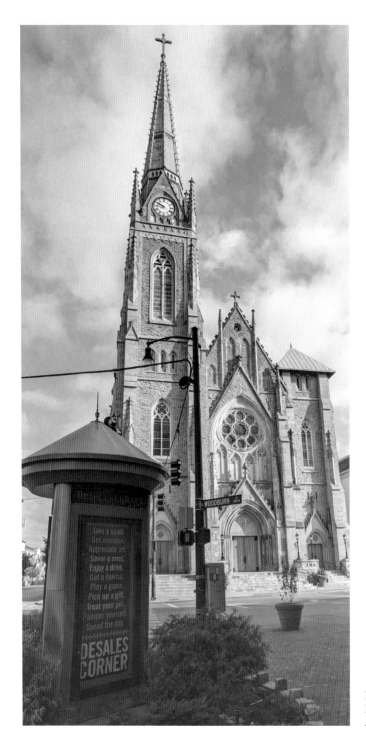

DeSales Corner,
East Walnut Hills.
Robert Schrage.

Top: DeSales Corner, East Walnut Hills. *Robert Schrage.*

Bottom: East Walnut Hills. *From the collection of the Cincinnati and Hamilton County Public Library.*

EXPLORING THE NEIGHBORHOODS: A SAMPLING

The history of each neighborhood is unique, and exploring them by car, public transportation or walking will provide a very rewarding adventure. It is not the intention of this chapter to explore in great depth the history of each neighborhood; rather, it is to introduce the reader to the endless possibilities of history exploration in each of these unique areas of Cincinnati. It could be in the West End that "from 1940–1970, when the political and social climate was in a slow crawl from segregation to integration and affirmative action. With its ever-changing boundaries, the West End was a citadel for a population in constant migration from the South to the North in search of positive economic, social, political, and educational opportunities."[73] Or it could be the walkable Mount Adams, with its beautiful vistas, homes and cultural attractions. The Price Hill neighborhoods are some of the oldest, and the area was home to one of Cincinnati's inclines. Visiting the site of the old incline is easy and provides excellent views of Cincinnati and the river. Cincinnati once had five inclines, including those in Price Hill (1874–1943), Fairview (1894–1923), Bellevue (1876–1926), Mount Auburn (Main Street, 1872–1898) and Mount Adams (1876–1948). In an article by John H. White Jr. for Cincinnati.com titled "Inclines Helped the City Spread Out":

All was not perfect. There were occasional fires. A tragic wreck on the Main Street Incline in 1889 killed six passengers, including Judge William W. Dickson, who commanded the city's Black Brigade during the Civil War. It closed in 1898. The inclines outlived their usefulness. They bottlenecked streetcar traffic, and automobiles were more convenient. But they were popular, so they stayed open. Maintenance became the excuse to finally close them down. The Mount Adams Incline, the last of the five in operation, closed for repairs in 1948 and never reopened.

On visiting Mount Auburn: "Today, the top of the old incline is now home to Jackson Park. A series of concrete steps follows the old path of the incline from the top at Jackson Park to the bottom at the intersection of Main and Mulberry Streets." Mount Auburn Incline was the first built and the first closed in Cincinnati.

Hyde Park is a great place to explore beautiful homes and a historic town square. In the center of the square is the Kilgour Fountain, originally installed in 1900. It was donated by John and Charles Kilgour. Hyde Park was annexed by the City of Cincinnati in 1903.

Cincinnati's West End, Linn Street at Olive Street, 1956. W. Reese Dry Cleaning can be seen on the left, and Frank's Grocery can be seen on the right. *Courtesy of the Kenton County Public Library*.

Price Hill incline. *Courtesy of the Kenton County Public Library*.

The location of the Price Hill incline from top. *Robert Schrage*.

Mount Adams streetscape. *Ann Schrage*.

Left: Hyde Park Square. *Robert Schrage.*

Below: Hyde Park. *From the collection of the Cincinnati and Hamilton County Public Library.*

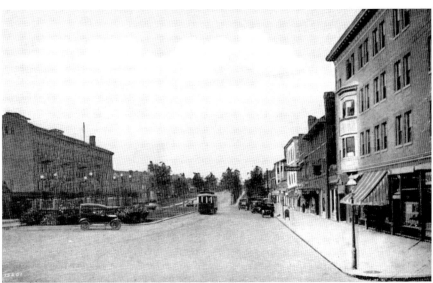

A unique statue can be found in Sayler Park, and it has an interesting history.

Cincinnati's smallest park, coming in at .010 acres, is located in the Sayler Park neighborhood of Cincinnati. The J. Fitzhugh Thornton Memorial at Thorton [sic] Triangle is a sculpture of an eastern Woodlands Native American and was created in 1912 by the J.L. Mott Iron Works of New York. The statue acquired the name Tecumseh, *after the Shawnee intertribal leader who led resistance against white expansion into our region. Its zinc composition and cast-iron pedestal make this work a unique*

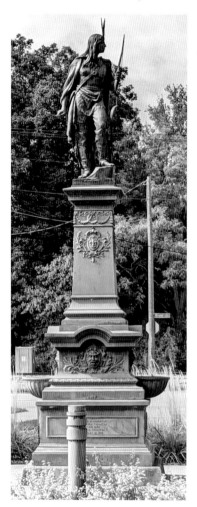

piece in the city. Only eight others like it have survived in the United States. A gift from Eliza Thornton in memory of her husband, this quaint statue in Thornton Triangle has seen much misfortune over the years. It was partially submerged in the great flood of 1937. Three years later, after being struck by a car, the city sold the sculpture for $10 to an antique dealer in Indiana. Outraged Sayler Park residents vowed to find and return the Indian to its pedestal. After several months, the sculpture was located and returned to Thornton Triangle, where it still stands today.[74]

Clifton was incorporated in 1850 and is home to many beautiful and historic homes, including Ludlow Avenue, with its shops, Art Deco movie theater and unique character. Camp Washington was home to an active military training camp during the Mexican-American War. Columbia Tusculum is considered to be the first neighborhood of Cincinnati and home to the "painted ladies," a distinct set of Victorian homes with multicolored painted façades.[75] Corryville is home to the University of Cincinnati, numerous hospitals and the street called Short Vine that has restaurants, shops and a historic

Sayler Park statue. *Ann Schrage.*

music hall called Bogarts. Westwood was incorporated in 1868 and was home to James Gamble. Westwood Town Hall and Park is operated by the Cincinnati Recreation Commission. Evanston is home to Xavier University, King Records and the renowned Walnut Hills High School. Mount Lookout is home to the Cincinnati Observatory and Ault Park.

CONCLUSION

All of these descriptions are but a small sampling of what can be found in the neighborhoods of Cincinnati. While they all exist within the boundaries of incorporated Cincinnati, each have a unique character, history and special place within the greater community. People who live in Cincinnati have a plethora of places they may call home, including the west side, east side, uptown, downtown or a specific neighborhood. The distinctions are real and a part of the fabric of the community. People in Cincinnati are proud of their neighborhoods and are not afraid to say so.

There are many resources for further exploration of these neighborhoods. Many of them have historical societies dedicated to the telling and preservation of their specific histories. Often, they have written histories and monthly meetings with speakers. Community councils exist, providing an important link between the neighborhoods and the city government. Some neighborhood books exist, providing valuable current and historical information. Exploring the city's large number of neighborhoods will certainly take time. Tourists will probably concentrate their limited time on what they are most interested in, often exploring the downtown area. However, for area residents, exploring these neighborhoods is well worth the investment.

PROFESSIONAL SPORTS IN CINCINNATI

rofessional sports have been a part of the fabric of Cincinnati since the
founding of its first professional baseball team in 1869. This chapter
will provide an overview of the professional teams that have called
Cincinnati home. It will include major-league baseball, football, soccer,
basketball and hockey teams.

BASEBALL: THE CINCINNATI REDS

Cincinnati was home to the nation's first professional baseball team, the Red
Stockings, which began playing in 1869. The year 1869 was historic for
many reasons, including the women's suffrage movement, a great financial
Wall Street panic, the creation of the table of elements and the golden spike
being driven into the transcontinental railroad. Many didn't notice what
took place in Cincinnati, although it did shake the amateur baseball world.[76]

Harry Wright was a jeweler and the head of an amateur baseball club. He
was paid $1,200 to play center field for and manage the Red Stockings. The
team's only local player was Charlie Gould. Its other players were George
Wright (Harry's brother), Asa Brainard, Fred Waterman, Charlie Sweasy,
Doug Allison, Andy Leonard, Cal McVey and Dick Hurley (a substitute).
The team would travel eleven thousand miles and have a record of fifty-
six wins and one tie.[77] Due to mounting salaries and some losses, the team
was disbanded in 1870. According to the *Baseball Encyclopedia, Seventh Edition*,

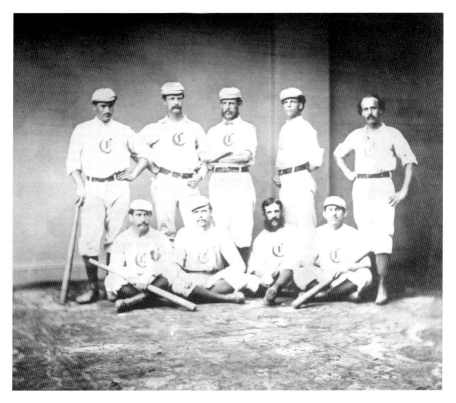

1869 Red Stockings. *From the collection of the Cincinnati and Hamilton County Public Library.*

this was not "before they gave an important piece of heritage to American history. The Red Stockings were a revelation, uprooting the foundation of amateur baseball and replacing it with a caliber of play that paved the way for the first professional league." The National Association of Professional Baseball Players was organized in 1871 with nine charter members. Interest in the new league faded due to gambling and bribery interests, and it was disbanded.[78] The National League was founded in 1876, and eventually, Cincinnati was expelled (after the 1880 season) for selling beer and playing on Sunday. The American Association was formed a year later at the Gibson Hotel, and Cincinnati became a charter member. The Red Stockings joined the National League after leaving the American Association in November 1889, and the team has been a member ever since.

Today, the Cincinnati Reds play at Great American Ballpark. Outside the park is the 1869 Red Stockings Pavilion. It is a well-made monument and tribute to the original team and is worthy of a visit. Just to the side of the

The 1869 Red Stockings Pavilion. *Kevin T. Kelly.*

pavilion is a marker signifying the spot where Pete Rose's 4,192[nd] hit landed on September 11, 1985, breaking Ty Cobb's all-time record.

Throughout the years, teams would go back and forth with their names, specifically the Cincinnati Reds (1959–present), Cincinnati Redlegs (1954–1958), Cincinnati Reds (1890–1953) and Cincinnati Red Stockings (1882–1889). The team has won the World Series five times, in 1919, 1940, 1975, 1976 and 1990. The years of the Big Red Machine in the 1970s are considered the best years of Cincinnati baseball history. That team won the World Series in 1975 and 1976. They lost in the World Series in 1970 and 1972.

Riverfront Stadium followed Crosley Field (1912–1970) as the home of the Cincinnati Reds. It was located just to the west of the current Great American Ballpark. While the lifespan of Riverfront Stadium was relatively short (1970–2002), its history was tremendous. The original home plate can be found in the Central Riverfront Garage along Mehring Way. It is located near an elevator and steps at the P2 level, K aisle. The first base can be found at nearby Moerlein Lager House at 115 Joe Nuxhall Way. Its plaque reads, in part, "This marks the exact location where Pete Rose and the baseball world enjoyed a nine-minute standing ovation," when Pete Rose singled to break Cobb's record. Riverfront Stadium, later called by other corporate names, was razed in 2002.

Crosley Field was located at Findley and Western Avenues and was home to the first major-league night game under the lights. Earlier fields occupied this spot, including League Park (1884–1901) and Palace of the Fans (1902–1911). A memorial to Crosley Field can be found at the original site. It points out that on the day Redland Field (later changed to Crosley) opened, April 12, 1912, the *Titanic* was out to sea. Bases and a home plate have been placed in the area to mark the spots where they were located at Crosley. First and second bases are located within the City Gospel Mission building at 1805 Dalton Street. City Gospel Mission is dedicated to "breaking the cycle of poverty and despair…one life at a time." The staff at City Gospel are very friendly, and visitors to the Crosley Field site are welcome to go in the building for a visit. Within the building are historic baseball photographs that are worth seeing. City Gospel will even provide visitors with a free walking guide/brochure on the building's historic surroundings. Outside the mission, it is easy to see the location of home plate and third base. A highlight for this author was second base (in the City Gospel cafeteria). On August 21, 1966, the Beatles performed at Crosley Field on a stage built over second base. Also, for many years at Crosley, Pete Rose played second base for the Reds.

Left: Riverfront Stadium's home plate location. *Robert Schrage.*

Below: Crosley Field memorial. *Robert Schrage.*

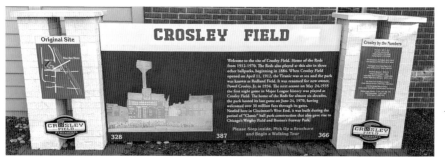

Great American Ballpark's features include statues outside the park that are dedicated to Red's greats, the power stacks in right center field, the notch (a break in the stands with a great standing view for watching the game), a large mural called the *Spirit of Baseball* near the main entrance, mosaics inside the front gate that feature the "first nine" Red Stockings and the Big Red Machine and, finally, the beautiful views of the Ohio River from the stands. Next to the ballpark is the previously mentioned Reds Hall of Fame and Museum.

If the reader of this guide happens to be in Cincinnati on opening day of the Reds season, the Opening Day Parade is a great piece of history. The parade has been a proud baseball and community tradition since 1920. It starts at historic Findlay Market, goes through Over-the-Rhine and ends downtown.

As a final baseball sidenote, Cincinnati was home to two professional softball teams in the late 1970s and 1980s: the Cincinnati Suds (1977–1982) of the American Professional Slo-Pitch League (1977–1980) and United Professional League (1981–1982) and the rival Cincinnati Rivermen (1980) of the North American Softball League.

PROFESSIONAL FOOTBALL

According to the Ohio History Connections web page:

> The first professional football team to be called the Cincinnati Bengals began playing in Cincinnati, Ohio, in 1937. This team was part of the American Football League, which folded following the 1937 season. This Bengals team had a combined record of two wins, four losses and two ties. The team continued to play during 1938 as an independent team, and then in 1939, it joined a new American Football League, which folded that same year. In 1940, a third American Football League formed, and the Cincinnati Bengals joined it. Unfortunately, World War II began the following year, causing manpower shortages as men joined the armed forces. This prompted the newer AFL to cease playing after the 1941 season.

Two other professional football teams existed in Cincinnati. The Cincinnati Celts (1921) of the American Professional Football Association (later named the National Football League) was the first professional football team in Cincinnati. After one year and financial hardships, the team played as an amateur team for two years. The Cincinnati Reds played in the National Football League in 1933 and for part of the 1934 season.

> The Reds hold the dubious distinction of having the two lowest officially recognized season scoring totals in NFL history. In 1933, they scored 38 points in 10 games, tying the 1942 Detroit Lions for second on that list. In 1934, the Reds and Gunners (the Reds was eventually suspended for failure to pay league dues during the 1934 season, and the St. Louis Gunners, an independent team, replaced the Reds on the schedule for the

last three games) combined for only 37 points in 11 games, with the Reds themselves scoring only 10 points in 8 games before their suspension. The franchise was shut out in 12 of its 18 games.[79]

In 1967, Paul Brown, the former coach of the Cleveland Browns, was awarded a franchise in the American Football League (AFL). He chose the nickname "Bengals" to memorialize the old Cincinnati teams of the same name. The AFL completed a merger with the National Football League in 1970. Brown would coach the Bengals until 1975. The team began playing at Nippert Stadium on the campus of the University of Cincinnati in 1968 and moved to Riverfront Stadium in 1970. They saw fast success, making the playoffs in 1970, 1973 and 1975. Today, the NFL Bengals play at Paycor Stadium on the west side of downtown on the Ohio River. The "jungle," as it is unofficially known, opened on August 19, 2000. It was named Paul Brown Stadium until 2022.

Paycor Stadium houses the Cincinnati Bengals Pro Shop. Nearby are the team practice fields.

Cincinnati was home to several arena/indoor football teams over the years, including the Rockers (1992–1993), Swarm (2003), Marshals (2004–2006), Jungle Kats (2007) and Commandos (2010–2012). A very minor professional football league called the Midwest Football League existed from 1935 to 1940. In the league, the Cincinnati Blades disbanded after playing three games in 1938, all victories.

SOCCER

In 2018, Cincinnati was awarded a Major League Soccer (MLS) franchise. Prior to joining the MLS, FC Cincinnati played in the United Soccer League. Their matches were held at Nippert Stadium on the University of Cincinnati Campus. The crowds were large and broke league attendance records. FC Cincinnati began playing in the MLS in 2019 and now hold home matches in TQL Stadium, a soccer-specific stadium in Cincinnati's West End. It has a capacity of twenty-six thousand. FC Cincinnati made the playoffs for the first time in their MLS history in 2022.

In the past, Cincinnati has had numerous professional soccer teams, mostly with indoor leagues. The following is a list of previous teams: Cincinnati Kids (1978–1979), Cincinnati Riverhawks (1997–2003), Cincinnati Silverbacks (1995–1998), Cincinnati Excite (2004–2008), Cincinnati Kings (2008–2013) and Cincinnati Saints (2013–2014).[80]

BASKETBALL

Cincinnati has been home to two professional basketball teams, the most important being the Cincinnati Royals of the National Basketball Association. The team relocated from Rochester, New York, in 1957 and played in Cincinnati until 1972. Early on, the team did not perform well on the court, but when future hall-of-famers Oscar Robertson and Jerry Lucas joined the team, things changed. In 1963, the Royals had the second-best record in the NBA. The year 1964 saw Robertson win the Most Valuable Player Award and Lucas the Rookie of the Year Award. The Royals never won an NBA Championship in Cincinnati. The home of the Royals was Cincinnati Gardens, which was opened in 1949 at 2250 Seymore Avenue in Bond Hill. It hosted the 1966 NBA All-Star Game. The Gardens was demolished in 2018. The Royals moved to Kansas City in 1971 and became the Kings. In 1985, the franchise moved to Sacramento.

The Cincinnati Slammers were a professional team in the Continental Basketball League. The team played in Cincinnati from 1984–1987. Due to poor attendance and financial losses, the team relocated to Cedar Rapids before the 1988–89 season.

HOCKEY

Cincinnati has a great tradition of minor-league hockey, starting with two Mohawks teams, which operated in two different leagues from 1949 to 1958. The first Mohawks team (1949–1952) played in the American Hockey League and were the farm team of the Montreal Canadiens and, later, the New York Rangers.

> [The second Mohawks team (1952–1958)] *were loaded with highly-talented young players, such as Phil Goyette, Don Marshall, Charlie Hodge, Duke Edmundson, Billy Goold, John "Bun" Smith, Eddie Kachur, and coach Rollie McLenahan. Most of the club's players were provided by the Montreal Canadiens. While the Canadiens dominated the National Hockey League during the era, and the Mohawks dominated the IHL. In their six-year stint in the league, Cincinnati's dynasty won six straight regular season titles and five Turner Cup Championships. The IHL never saw another club match the Mohawks success during its 56-year run as a league.*[81]

Other minor-league hockey teams in Cincinnati included the Wings (1963–1964), Swords (1971–1974), Cincinnati Stingers (the minor-league team, 1979–1980) and the Mighty Ducks (1997–2005). The Cyclones are the longest-serving hockey team in Cincinnati history. Founded in 1990, they first played at Cincinnati Gardens and now play at Heritage Bank Arena.

The Stingers also played at the arena and are the only major-league hockey team to ever form in Cincinnati.

> *The Stingers franchise was awarded in 1974 as part of the WHA's ill-conceived attempt at expansion. They entered the league for the 1975–76 WHA season, along with the Denver Spurs. Most of the league's existing teams were not financially stable, and franchise relocations were commonplace. The Stingers achieved enough stability that they were the only one of the WHA's five expansion teams that lasted through to the end of the league, but they were left out of the NHL–WHA merger in the summer of 1979. The WHA insisted on including all three of its surviving Canadian teams, though below-average attendance made it unlikely that the Stingers would have made the cut. The Stingers, along with the Birmingham Bulls, were paid to disband when the WHA ceased operations.*[82]

CONCLUSION

Today, Cincinnati is home to three major-league teams, but it also has a tremendous history of minor-league franchises. Opportunities to see the locations of this history firsthand are limited, and the Reds Hall of Fame and Museum offers the best opportunity to learn about baseball. Sites around Great American Ballpark and the former Riverfront Stadium also offer some historic points of interest. Visiting the site of Crosley Field provides a quick and interesting trip. Taking in a Cyclones game is enjoyable and sometimes brings back memories of going to Swords and Stingers games. The Cyclones have a history of fielding a competitive team and have won championships. Cincinnati is certainly a sports town, and its history is both interesting and enjoyable to read about and explore when possible.

PRESIDENTS IN CINCINNATI

As Ian Strock said in his book *The Presidential Book of Lists*, about the presidency: "Created in the late 1700s, it was designed incredibly well, able to weather the vagaries of external and internal wars, good and bad presidents, and happy and sad times in the country." As stated in a previous book of this author's titled *Eyewitness to History: A Personal Journal*, "Nothing in my mind compares to the historic feel and experience of a presidential inauguration. It is the crème da la crème of history. The peaceful transfer of power from one president to another is the greatest experience of history watching." Each presidential era defines a different time in American history. Cincinnati has played a small part in presidential history, and the purpose of this chapter is to explore some of the people and events that played a role. This chapter is not focused on visits by presidents (or future presidents), unless they were very significant. All major cities are visited on a regular basis by campaigning candidates. Thus, a campaign visit is not what the chapter is about. Of interest here are presidents to whom Cincinnati was important—and vice versa.

JOHN QUINCY ADAMS'S VISIT IN 1843

John Quincy Adams was not a particularly successful president. However, he was one of the best ex-presidents, as he had a long career of public service following his presidential term. He lost his bid for a second presidential term

in 1828, but in just two short years, he was elected to the United States House of Representatives by Massachusetts. He would serve in that capacity for nine terms until his death in 1848. Five years before his death, at the age of seventy-six, he traveled to Cincinnati. Adams, the son of the second president of the United States, had a love of astronomy, and his main purpose in visiting was to lay the cornerstone of the Cincinnati Observatory, located on Mount Ida.

Adams was not feeling well upon his arrival in Cincinnati. He was put in a barouche (by definition, a four-wheeled horse-drawn carriage with a collapsible roof over the rear half). According to an article written by Heather Rockwood for the Massachusetts Historical Society, "His arrival in Cincinnati on Wednesday, 8 November 1843, he writes of having a cold with 'head ache, feverish chills, hoarseness, and a sore throat and my tussis senilis in full force.' Tussis senilis was the name for a severe, chronic cough, but he also named one of his ailments as catarrh, or a buildup of mucus in the throat. His diary goes on to mention waking up several times during the night, something he records often on the later leg of his journey." Adams was welcomed by a large crowd, and according to Rockwood, "the day of the stone laying for the Cincinnati Observatory, Adams had been working on his address during his travels but notes in his diary his difficulty writing it because of the cramped conditions, the weather, his cold, and the company around him." Rockwood continued:

> *Nevertheless, he finished the address before breakfast the morning of the stone laying. To get to the observatory, another barouche was set up to include the mayor and the president of the astronomical society. The procession also included carriages with other important Cincinnatians, a military escort, a band and a crowd of supporters to walk beside the carriages. Then it started to rain. The cover of the barouche had to be lifted to protect the dignitaries from the rain, and in effect it "exclude[d] the sight of me from the people and of the people from me. But the procession continued." In his diary from November 9 ,1843, Adams writes: "The procession marched round sundry streets, the rain increasing till it poured down in torrents. Yet the throng in the streets seemed not at all to diminish—It looked like a sea of mud—The ascent of the hill was steep and slippery for the horses, and not without difficulty attained—The summit of the hill was a circular plain of which the corner stone was the centre. At the circumference, a stage was erected from which my discourse was to have been delivered; but the whole plain was covered with an auditory of Umbrella's instead of faces."*

After the cornerstone was placed and Adams read his address, the discourse portion of the day was postponed. It was given the next day in a chapel.[83] On his third day in Cincinnati, Adams gave an approximately two-hour-long speech. In the evening, according to his diary, he went to the theater and a ball: "After hearing part of two acts without understanding the plot of the play, we retired and went to a ball at Mr. Springer's, an opulent citizen of Cincinnati—The Ball was splendid—the banquet sumptuous and temperate and the company genteel and lovely—Thus closes, blessed be God one memorable day of my life."

The cornerstone of the observatory states it was laid by John Quincy Adams on November 9, 1843, and it can be seen today. Of course, as mentioned earlier in this book, the observatory was later moved to Mount Lookout, and so was the cornerstone. It is now laid on the Hannaford building. After the third day of speeches, Mount Ida was quickly named Mount Adams in honor of the sixth president. The observatory was moved in 1871 to its current location. The original site became Holy Cross Monastery. It closed in 1977 and was later redeveloped.

HERBERT HOOVER JUST BEFORE STOCK MARKET CRASH

President Herbert Hoover was in Cincinnati on October 22, 1929. He had lunch at the Gibson Hotel, attended by nine hundred people, and he visited his friend Nicholas Longworth III at his home on Grandin Avenue.[84] By 1923, a total of $56 million had been allocated by Congress for the completion of the Ohio River Dams. They were completed by 1929, and touring these dams was the purpose of Hoover's wider Ohio River tour. In Eden Park, the president dedicated a monument. The monument still exists at the overlook behind the Krohn Conservatory. It is one of the most beautiful spots for observing the river below. The monument was made to mark the completion of the canalization of the river to a depth of nine feet from Pittsburgh to Cairo, a distance of 981 miles. Northern Kentucky, situated on the other side of the river, is visible from here. Standing at the monument, it is easy to envision Hoover observing the river itself, which has not changed much.

Following the day's activities, Hoover boarded the *Greenbrier* and headed to Madison, Indiana. It was cold and rainy.[85] Six days after visiting Cincinnati, Black Tuesday occurred as the stock market crashed, starting the Great Depression.

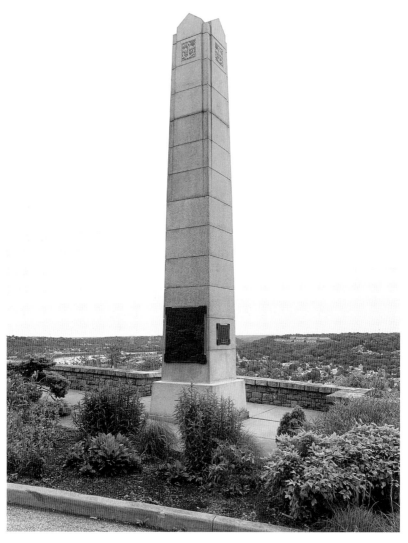

Mount Adams monument dedicated by President Hoover. *Robert Schrage*.

In 1931, President Hoover and his wife attended the funeral of Nicholas Longworth III in Cincinnati. Longworth was a congressman, speaker of the United States House of Representatives and great-grandson of Nicholas Longworth I. The Longworth House office building in Washington, D.C., is named for him. Longworth was married to Alice Roosevelt, the oldest child of Theodore Roosevelt.

WILLIAM HENRY HARRISON

William Henry Harrison.
From the collection of the Cincinnati and Hamilton County Public Library.

William Henry Harrison was the last non-native president. Born in 1773, he was buried near Cincinnati. A war hero, Harrison began studying medicine; however, being a youngest son, "there was little hope of him ever receiving any of his father's inheritance. Instead, William, at the age of 18, and possibly on the recommendation of George Washington, gave up his brief stint studying to become a doctor and took a commission as ensign in the First Infantry of the regular army."[86] As a result, Harrison was sent west to Cincinnati and stationed at Fort Washington. There are two sites worthy of visiting in the Cincinnati region related to Harrison. The first and most significant is his grave in the North Bend area. While it is not located in Cincinnati proper, it is close. Harrison died in 1841, after serving as president for only a month. Harrison wanted to be laid to rest in North Bend, with its "wide view of the Ohio River and of the corners of three states—Ohio, Indiana and Kentucky. Nearby is Congress Green Cemetery, the family burial grounds of his in-laws, the Symmes." His body was brought back in a river procession of black-draped barges. He was buried on July 7, 1841, in a simple family tomb on the summit of Mount Nebo. In 1871, the Harrison family sold their estate, with the exception of the six acres comprising Congress Green Cemetery. That same year, the president's son John Scott Harrison offered the site and the tomb to the State of Ohio on the condition that it be preserved. The tomb has twenty-four vaults that contain the bodies of William Henry Harrison; his wife, Anna, who died in 1864; their son John Scott, the father of President Benjamin Harrison; and other members of the family. Several sealed vaults are unmarked."[87]

North Bend is one of only two towns that can claim two presidents, the other being Quincy, Massachusetts. William Henry Harrison's grandson Benjamin was also born in North Bend.

Benjamin Harrison, who was elected president in 1888, attended Farmer's College in Cincinnati before transferring to the University of Miami in Oxford, Ohio. It was in Cincinnati, at Farmer's College, where Harrison met his first wife, Caroline Lavinia Scott, who passed away as the first lady in 1892. She was the second first lady to die while serving in that role.[88]

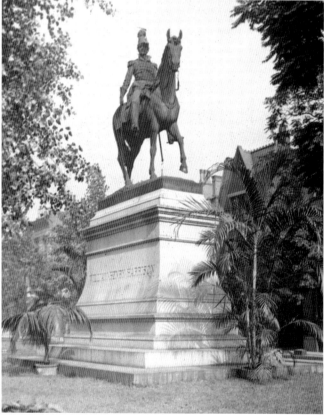

Above: William Henry Harrison's tomb prior to restoration. *From the collection of the Cincinnati and Hamilton County Public Library.*

Left: Historic Harrison statue in downtown Cincinnati. *From the collection of the Cincinnati and Hamilton County Public Library.*

In Piatt Park downtown, there is a handsome statue of W.H. Harrison. It was originally dedicated in Chicago as part of the Ohio Exhibition at the World Columbian Exposition in 1892. President Benjamin Harrison (the grandson of W.H. Harrison) and Ohio governor William McKinley gave speeches at the dedication. The statue was eventually moved and unveiled in Piatt Park in 1896. It is the only equestrian statue in Cincinnati.[89]

The William Henry Harrison house in North Bend no longer exists.

GRANT MEETS WITH SHERMAN

On Sunday March 20, 1864, future president Ulysses S. Grant and General William Tecumseh Sherman met at the Burnet Hotel in Cincinnati, and according to CivilWarTalk.com, they went to the Burnet House to "coordinate their campaigns against Richmond, Virginia, and Atlanta, Georgia, eventually leading to federal victory in the American Civil War. After the American Civil War, 'Parlor A' was used by local veterans for the Grand Army of the Republic meetings." The 340-room hotel was considered one of the best in the world when it opened in 1850. According to a Civil War blogpost (June 15, 2020) titled "What was the Simple Strategy of Grant and Sherman," published on Shout-Questions.com:

> *The battle plan decided upon was simple but decisive. Sherman would command the western theater, destroy all rebel resources, pursue and annihilate General Joseph Johnston's Army of the Tennessee and basically cut the Confederacy in half. Grant would personally handle the rebellion in the eastern theater, attacking, holding and bludgeoning Robert E. Lee's Army of Northern Virginia into submission. "Yonder began the campaign," Sherman was to say a quarter century later, standing before the hotel on the occasion of a visit to the Ohio city. "He was to go for Lee, and I was to go for Joe Johnston. That was his plan. No routes prescribed....It was the beginning of the end as Grant and I foresaw right here."*

Many famous guests stayed at the Burnet house, including Abraham Lincoln (to be discussed later), Daniel Webster, Henry Clay, James Buchanan, Salmon Chase, Horace Greeley, Robert Lincoln and Susan B. Anthony. According to the historical marker at the spot, the hotel ceased operations on July 15, 1926, and was razed later that year. It stood at the corner of Third and Vine Streets downtown.

Burnet house. *From the collection of the Cincinnati and Hamilton County Public Library.*

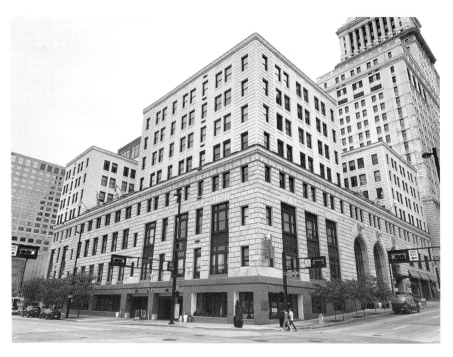

A current view of the Burnet house site. *Robert Schrage.*

RUTHERFORD B. HAYES

Rutherford B. Hayes was born on October 4, 1822, and served as the nineteenth president of the United States. Prior to his presidency, Hayes was a member of the U.S. House of Representatives and served as governor of Ohio. He was a lawyer, staunch abolitionist and Civil War veteran. His ties to Cincinnati were tremendous. It is safe to say his political career was started in Cincinnati.

Because Hayes heard from a friend "that Cincinnati was a growing city of 120,000 people and offered many opportunities, he decided to move to the city, where he established his permanent home in 1849."[90] In Cincinnati, he opened a law office at Third Street, between Main and Sycamore Streets, and from 1858 to 1861, he served as Cincinnati's city solicitor.

In Cincinnati, Hayes reconnected with Lucy Webb, and they were engaged in 1851 and married the next year. In Cincinnati, Hayes was a member of the Cincinnati Athletic Club and the Cincinnati Literary Club. The literary club was founded in 1849, and it occupies a Greek Revival house built in 1820, located at 500 East Fourth Street, across from Lytle Park. The building was not owned by the club during the time of Hayes, but it is a nice historical structure and typical of those that once existed on that section of Fourth Street.

Hayes was politically active. He left Cincinnati to serve in the Civil War and, on his return, resumed his political activities. He served in Congress from 1865 to 1867 as a Republican and left to run for governor of Ohio. Hayes was elected to two consecutive gubernatorial two-year terms and served from 1868 to 1872. After his second term ended, Hayes moved back to Cincinnati and opened an office at Sixth and Walnut Streets. Wanting to be out of elected office, he was drawn back in for many reasons and, despite his desires, was nominated to run for Congress. He lost his congressional election—the only election defeat of his career. He was then nominated for governor again; he was elected and served a little over a year starting in 1876.

Much to the benefit of Governor Hayes, the 1876 Republican nominating convention was held in Cincinnati at Exposition Hall (originally Saengerhalle). "Exposition Hall was a huge wooden structure measuring 250 feet long, 100 feet wide and 80 feet tall. Additionally, there were three other temporary buildings attached to it for a total floor space of 108,748 square feet—more than that of the 1853 World's Fair in New York City."[91] On the seventh ballot, with all opponents gone except Senator James G.

Left: The Literary Club house. *Robert Schrage*.

Below: 1876 Republican Convention, Exposition Hall. *From the collection of the Cincinnati and Hamilton County Public Library*.

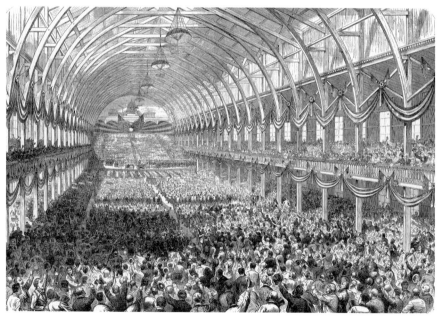

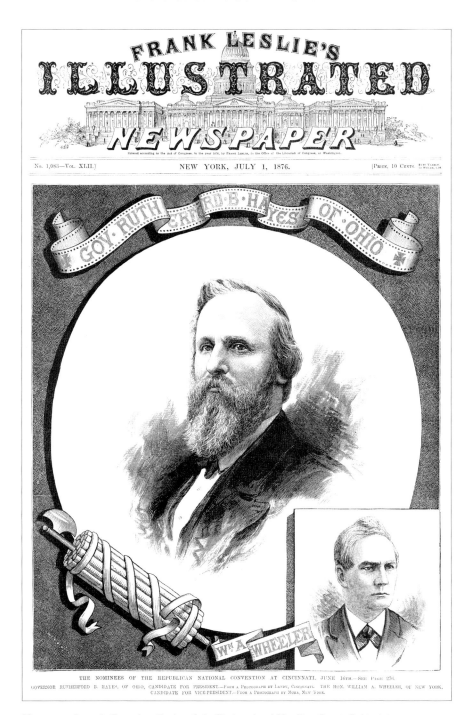

Hayes nominated. *From the collection of the Cincinnati and Hamilton County Public Library.*

Blaine, Hayes secured the nomination. Representative William A. Wheeler of New York was selected as Hayes's vice presidential nominee.

Saengerhalle was constructed as a temporary building in 1869 and later enlarged (1872) and renamed Exposition Hall. As stated, it was a temporary building, so it was demolished to begin construction of Music Hall on the same site.

Hayes would go on to lose the popular vote to Samuel J. Tilden, the governor of New York; however, neither secured enough electoral votes to win the presidency. The decision was turned over to the U.S. House of Representatives, which gave the victory to Hayes and Wheeler. The final electoral count was 185 to 184. True to his word, Hayes did not seek reelection four years later. He retired to his home at Spiegel Grove in Fremont, Ohio. According to author Rick Pender in his article "Presidents, Future and Former, Visited Music Hall, for the Friends of Music Hall": "As a past president then living in Fremont, Ohio, Hayes attended the Centennial Exposition of the Ohio Valley and Central States at Music Hall for Veteran Army and Navy Day in September 1888. Seventy prominent Grand Army men and their wives were escorted onto the stage of Music Hall. Hayes rode in a gondola, one of six, on the Miami and Erie Canal behind Music Hall. He was back in October 1888 to preside over the Exposition's 'Ohio Days.'"

As a sidenote, four years after Hayes's nominating convention, the 1880 Democratic National Convention was held at Music Hall and nominated Winfield S. Hancock of Pennsylvania as president and William H. English of Indiana as vice president. In a close contest, they were defeated by the Republican ticket of James Garfield and Chester A. Arthur.

In 1870, some powerful Republicans split off from the party to create the Liberal Republican Party. Their only nominating convention was held in Cincinnati in 1872.

LINCOLN IN CINCINNATI

It has been documented that Abraham Lincoln visited Cincinnati on three occasions. They are as follows: September 20–26, 1855, for the *McCormick v. Manny* trial; September 17–18, 1859, for his speech following the Lincoln-Douglas debates; and February 12–13, 1861, on the way to his inauguration as the sixteenth president of the United States. The following is a description of each of these visits.

McCormick v. Manny Trial

In 1855, Lincoln was invited to be a part of a legal team in the trial of *McCormick v. Manny*. McCormick sued John Manny, a mechanical reaper from Illinois, for a patent infringement. McCormick was a competitor of Manny.[92] The team included two prominent Pennsylvania attorneys: Edwin M. Stanton and George Harding. Lincoln was treated badly by Stanton, who would later serve as the secretary of war during his administration. This stands out as an early example of Lincoln's leadership style, as he appointed his presidential team based on their competency and other capabilities instead of focusing on their opposition to him personally and politically. As Doris Kearns Goodwin called it, he put together a "team of rivals." Things went wrong for Lincoln in Cincinnati. "When Lincoln tried to assist Stanton, a more established lawyer, [Stanton] called him a 'long, lank creature from Illinois,' wearing a dirty linen duster for a coat, on the back of which the perspiration had splotched wide stains that assembled a map of continent. At other times, Stanton called him a 'giraffe' and a 'long-armed baboon.' Lincoln complained to his partner, William Herndon, that he had been handled roughly."[93] According to historian and author Paul Tenkotte, in his article "Our Rich History: Abe Lincoln Visited This Area Several Times, Named Salmon P. Chase Chief Justice" for the *Northern Kentucky Tribune*:

> *Stanton and Harding had no respect for Lincoln. To them, he was an ill-educated, backwoods attorney, born in Kentucky, raised in Indiana and practicing law on the prairies of Illinois. In fact, although Lincoln was on their team, Stanton and Harding basically ignored him during the whole trial held in Cincinnati. They even turned down his invitations to dine with him. Nevertheless, Lincoln made the most of his visit, likely spending some time with his friend Richard Southgate at his home in Newport, Kentucky.*

Lincoln swore he would never return to Cincinnati.[94]

Follow-Up Speech to the Lincoln-Douglas Debates

In 1859, for a second time, Lincoln visited Cincinnati. This was a very historic visit, as Lincoln had become a national figure following the Lincoln-Douglas debates. Douglas had visited Cincinnati in early September and spoke on behalf of the Democratic Party. As Tenkotte says, "not to be

outdone," Lincoln was invited to speak in mid-September. Technically, he was there to support William Dennison Jr., a Republican who was running for governor. Foreshadowing how he would think and govern as president, Lincoln said, "I think slavery is wrong morally and politically. I desire that it should be no further spread in these United States, and I should not object if it should gradually terminate in the whole Union."[95]

According to author Ted Wilmer: "Cincinnati was kinder this time. Lincoln delivered a rousing outdoor speech from the balcony to a crowd that thrilled to his heated attack on slavery. Local accounts described an explosive evening. A cannon blast even made it into the official transcript, shattering glass nearby and interrupting him."[96] The building from which Lincoln spoke was located on the north side of Fifth Street at what is now Government Square. It is fair to say that speaking in Cincinnati played a role in endearing Lincoln to Ohio voters for the upcoming 1860 presidential election. In *Team of Rivals*, Goodwin quotes the *Cincinnati Gazette*'s description of the speech: "As an effort remarkable for its clear statement, powerful argument and massive common sense [and] of such dignity and power as to have impressed some of the ablest lawyers with the conclusion that it was superior to any political effort that they have ever heard."

Lincoln's 1859 speech. *From the collection of the Cincinnati and Hamilton County Public Library.*

During this visit, Lincoln stayed at the Burnet house.

On October 6, 1960, candidate for president John F. Kennedy spoke at this same Government Square location. He spoke again in the area in October 1962, and a plaque marks the spot where his podium sat. The plaque is located on a building on Fifth Street (south side) on the corner of Fifth and Walnut Streets. The plaque states the speech was given on October 8, 1962, but evidence shows the speech was actually delivered on October 5, 1962. President Lyndon Johnson spoke at Government Square on October 17, 1964. Some in the crowd were anti–Vietnam War protestors.

Lincoln's Last Cincinnati Visit: Traveling to His First Inauguration

On his fifty-second birthday, Abraham Lincoln arrived in Cincinnati to very large crowds while on the way to his inauguration as president. According to Tenkotte:

> *Arriving aboard the Indianapolis and Cincinnati Railroad, he was met by a carriage drawn by six white horses. Adorning the carriage were small 34-star flags. A flag fell from the carriage and was torn by one of the horses' hooves. A young boy named Charles Hanselman picked it up. Years later, the family donated the flag to the Public Library of Cincinnati and Hamilton County (PLCH). PLCH has beautifully restored the flag but, appropriately, kept the historic tear intact.*[97]

Lincoln arrived at the Burnet house (northwest corner of Third and Vine Streets) around 5:00 p.m., and the crowd was very thick and interfered in his attempts to get into the hotel.

> [However,] *he finally made it to the platform and gave a serious speech to "good old Cincinnati." Lincoln spoke chastely about his respect for all people on both sides of the Ohio—that he would treat them well, repeating a line from his speech two years earlier—"we mean to remember that you are as good as we are." He gave a second speech later at 8:00 p.m. from the balcony to 2,000 Germans who had descended on the Burnet "singing and carrying torches."*[98]

Speaking to a large group of German Cincinnatians in a community defined by their heritage, Lincoln said:

In regard to the Germans and foreigners, I esteem them no better than other people, nor any worse. It is not my nature, when I see a people borne down by the weight of their shackles—the oppression of tyranny—to make their life more bitter by heaping upon them greater burdens; but rather would I do all in my power to raise the yoke, than to add anything that would tend to crush them. Inasmuch as our country is extensive and new, and the countries of Europe are densely populated, if there are any abroad who desire to make this the land of their adoption, it is not in my heart to throw aught in their way, to prevent them from coming to the United States.[99]

A plaque on Vine Street marks the location of the Burnet house. The balcony was around the corner from the plaque.

The inaugural train ride from Springfield to Washington, D.C., was grueling for Lincoln, and Cincinnati was only the second stop. In many ways, it is amazing that harm did not come to Lincoln during his travels to Washington. There were credible threats to his life, the crowds were enormous, Lincoln was awash in the throngs of people, his time was monopolized by visitors and security was weak. Lincoln surviving the train trip to Washington is one of the most underappreciated, lucky and forgotten pieces of American history.

On February 13, 1960, the Lincoln train left Cincinnati for Columbus.

The Assassination of Abraham Lincoln

April 14, 1865, was a day of tremendous celebration in Cincinnati.

This celebration was not merely a few "hip, hip, hurrays [sic]" but a splendid triumph and transcendent merrymaking. From dawn to midnight, Cincinnatians rejoiced in the grandest municipal expression of thanksgiving and glee that the city had ever known. The celebration literally began at dawn. Morning bells of all Cincinnati churches began to peal as soon as early light creased the Queen City skies. Canon thunder from surrounding hills joined the clangor and aroused the steamboats at the public landing to belch out in their finest stertorous basses.[100]

The Civil War was over!

Junius Brutus Booth Jr.

Junius Brutus Booth Jr.
Courtesy of the National Archives.

At any other time, Cincinnatians would have gone in droves to the theater to see "Junius Brutus Booth Jr. play Shylock at Pike's Opera House, but they preferred the spectacle outside, so Booth played to an almost empty house. The night before, he had done much better business as Iago."[101] Around 3:00 a.m. on the morning after Lincoln's assassination, reports talked about a shooting in Washington. "They were garbled, but their essence was that both the president and the secretary of state had been killed by assassins. Thus began a trying time for both the nation and Cincinnati."[102]

As described by Robert Herron in his excellent article "How Lincoln Died in Cincinnati," this is what happened next:

The one person in town most immediately in danger from the crowd was, through the time-honored logic of guilt by association, Junius Brutus Booth Jr., half-brother of the assassin. Early that morning, he appeared at the theater for rehearsals and was told that his brother had shot the president. "My God! Can it be possible?" he exclaimed, then fell in a faint. He was taken back to the Burnet house, where he was staying. By noon of the 15th, an angry crowd had assembled in front of the hotel on Third Street and called upon the management to deliver Booth to their hands. Part of the crowd broke off and marched a block up Vine Street to the opera house, where posters stood with Booth's billing. Colonel Samuel Pike, owner of the theater, had anticipated this action and stood on the sidewalk in front of the bulletin board. When a young man rushed past him to rip a poster, Colonel Pike, not easily intimidated by a mob, knocked him down. The crowd at once returned to the Burnet house to join the others calling for Booth's blood. Their demands proved fruitless, because the management had bundled the actor out the rear entrance of the hotel and must have hidden him in a private residence throughout the following day. On the morning of the 17th, at 10:30, Booth caught a train to Philadelphia to meet with his family, but the trip turned out badly. He missed his connection the next morning while eating breakfast at Crestline, Ohio. Once in Philadelphia, federal agents gave him only a short time with his family before arresting him for suspected

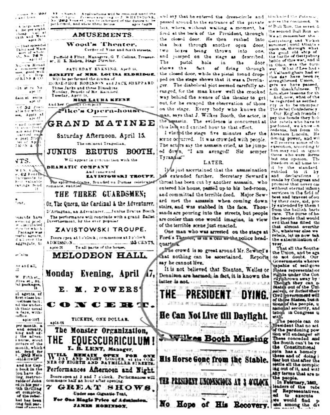

A Cincinnati newspaper following the assassination. *Archives of the* Cincinnati Commercial, *dated April 15, 1865; courtesy of the Cincinnati Museum Center.*

complicity in the crime. He was taken to Washington and jailed for thirty days but was released for lack of evidence.

In an interesting newspaper section from the *Cincinnati Commercial*, on one page there is an article about the Lincoln shooting, an advertisement for Junius Brutus Booth's performance at Pike's Opera House and an advertisement for Laura Keene's upcoming performance at Wood's Theater. Pike's Opera House was located on Fourth Street between Vine and Walnut Streets.

As another interesting footnote to the Booths in Cincinnati, Junius Brutus Booth Sr., the father of Edwin, John Wilkes and Brutus Jr., boarded a steamboat from New Orleans to Cincinnati in 1852. He died five days into the voyage near Louisville, and his body was sent to Cincinnati, where it was claimed by his wife, Marie Christine Booth. He was fifty-six years old.

Laura Keene

The British actress Laura Keene was born July 20, 1826, and had an acting and theater management career that spanned twenty years. She is most widely known for her role in the play *Our American Cousin* at Ford's Theater in Washington, D.C., on the night of April 14, 1865. In attendance that night were President Lincoln and his wife, Mary Todd. Also starring in the play were actors John Doytt and Harry Hawk. While on stage alone, Hawk delivered what was considered the funniest line of the play: "Don't know the manners of good society, eh? Well, I guess I know enough to turn you inside out, old gal; you sockdologizing old man-trap!" Lincoln was probably laughing when John Wilkes Booth shot him. Booth leapt to the stage as Hawk backed up, thinking he was being attacked. Booth exited the theater.

Laura Keene immediately went to the presidential box and cradled the president, reportedly getting blood on her dress. A week after the assassination, Laura Keene came to Cincinnati. According to Herron:

> *The fated performance had been the last one scheduled in Washington for that run, and the company's plans were to leave a day or so later in order to open in Cincinnati on the 20th of April in She Stoops to Conquer. But the troupe arrived a day late. Mr. Hawk, the actor playing Lord Dundreary the night of the assassination and the only person onstage at the time it took place, had been detained a while in Washington for questioning, thereby causing the entire company to miss connections at Harrisburg. A Cincinnati newspaper became confused about the whole affair and reported that Miss Keene had been arrested in Harrisburg on suspicion that she was involved in the crime.*

According to the Civil War Blog *Laura Keene and the Bloody Dress in Cincinnati*: "At Harrisburg, the company trunks and Laura's piano had to be loaded onto the Pennsylvania Railroad train to Pittsburgh. Lutz made these arrangements after he purchased the tickets. The dress that Laura wore in act III of *Our American Cousin* was in one of Laura's trunks. She was carrying the dress because she planned to wear it in one of the performances at Wood's Theatre in Cincinnati."

Woods Theater was located at Sixth and Vine Streets downtown. Lousia Eldridge, a stock company actress, said, "She [Keene] then told me the entire story of the assassination and how she went into the box at Ford's Theatre, Washington, and held the head of the murdered president. She also gave me a piece of the dress she wore at the time. I cannot now find

the scrap, as it is more than thirty years since that sad event took place."[103] This is the same Eldridge who appears in the newspaper section discussed previously announcing Keene's appearance in Cincinnati at the time of the assassination. The dress made it to Cincinnati.

Laura Keene died of tuberculosis at the age of forty-seven in 1873 and was buried in Brooklyn.

WILLIAM HOWARD TAFT

William Howard Taft was both the twenty-seventh president of the United States and, later, the chief justice of the supreme court. Born and raised in Cincinnati, Taft is by far the most visible of the presidents associated with Cincinnati, with many public streets and buildings named after him.

Taft was born in the Mount Auburn section of Cincinnati on September 15, 1857. He attended and graduated from Woodward High School and went on to Yale and the University of Cincinnati Law School. His career was impressive and included time serving as solicitor general of the United States, judge on the United States Court of Appeals, governor-general of the Philippines, first provisional governor of Cuba, secretary of war and, of course, president and, later, chief justice.

There are two noteworthy sites to visit in Cincinnati related to Taft. The first is the William Howard Taft National Historic Site, located at 2038 Auburn Avenue. The site is his birthplace and boyhood home, and it was where he lived until he headed off to Yale in 1874. Alphonso Taft, his father, arrived in Cincinnati in 1838 to open his law practice, and he moved into the house around ten years later. Alphonso would later serve as the secretary of war and United States attorney general. He was buried in Spring Grove Cemetery. The house was most likely built in the early 1840s and, according to the National Park Service, is a "Greek Revival domicile [and] was relatively modest compared to other nearby residences, which were a mix of Second Empire, Italianate and Georgian Revival."

The national historic site includes the residence and a visitors' center. It is only about a mile from downtown Cincinnati.

The second noteworthy site is the Taft Museum of Art, featuring a collection of art in a two-hundred-year old-house. It is located at 316 Pike Street downtown. The house was built in 1820 and was later the residence of Nicholas Longworth. Even later, the house was purchased by David Sinton, who was the father of Anna Sinton Taft. Anna married Charles Phelps Taft,

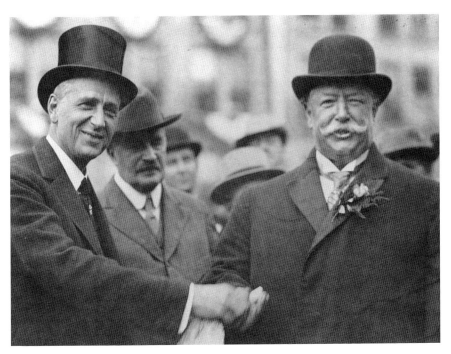

Former president William Howard Taft in Cincinnati at the cornerstone laying of the Hamilton County Courthouse (1915). Senator Warren G. Harding would speak at the building's dedication in 1919. *From the collection of the Cincinnati and Hamilton County Public Library.*

Taft Museum of Art. *Ryan Kurtz Photography; courtesy of the Taft Museum of Art, Cincinnati, Ohio.*

William Howard Taft accepting the Republican nomination for president in Cincinnati. *Courtesy of the Taft Museum of Art, Cincinnati, Ohio.*

the half-brother of William Howard Taft. "The Tafts lived in the house from 1873 until their respective deaths in 1931 and 1929."[104] The most significant historic event related to William Howard Taft occurred there on July 28, 1908. From the porch of this home, William Howard Taft accepted his Republican nomination for president of the United States. The museum is a tremendous place to visit, with a full program of special exhibits. However, for lovers of presidential history, the front porch stands out.

As a final note, a statue of Taft sits at the University of Cincinnati College of Law.

CONCLUSION

This chapter has outlined numerous pieces of Cincinnati presidential history. Of course, all modern presidents have visited the Queen City before their terms, while in office and afterward. This author, for example, attended many such events, including one on July 3, 1975, when President Gerald Ford spoke at the dedication of the Environmental Research Center. On September

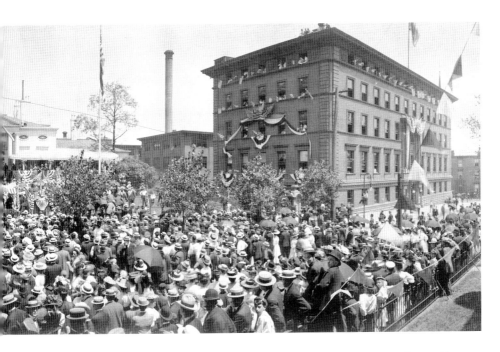

22, 2011, President Barack Obama spoke at a site near the Brent Spence Bridge to talk about infrastructure and the need for a new bridge. It would take ten more years to pass an infrastructure bill in Congress. George W. Bush delivered major remarks on the Iraq War on October 7, 2002, at the Cincinnati Museum Center. On the night of the Virginia primary, February 29, 2000, Bush campaigned at Memorial Hall. On Sunday November 2, 1980, candidate Ronald Reagan and former president Ford campaigned for two days before the historic presidential election of 1980. Their special guests included Bob Hope, Hugh O'Brian and Charlton Heston. After his presidency and soon after having brain surgery, former President Ronald Reagan met Israeli prime minister Yitzhak Shamir at the Cincinnatian Hotel. On July 5, 1948, two presidents, President Harry Truman and President Romulo Gallegos of Venezuela, went through Union Terminal for a half-hour train service stop. Truman made another half-hour stop at Union Terminal on November 5, 1948. Truman spoke at Music Hall on November 1, 1952, three days before Eisenhower was elected president. Former president Eisenhower visited Cincinnati on June 12, 1961. Candidate Jimmy Carter held a rally at Lunken Airport on October 17, 1976, a few weeks before being elected president.

President Richard Nixon visited several times as a presidential candidate, including a visit for a 1968 rally at Cincinnati Gardens. President Nixon threw out the first pitch at the 1970 All-Star game at the new Riverfront

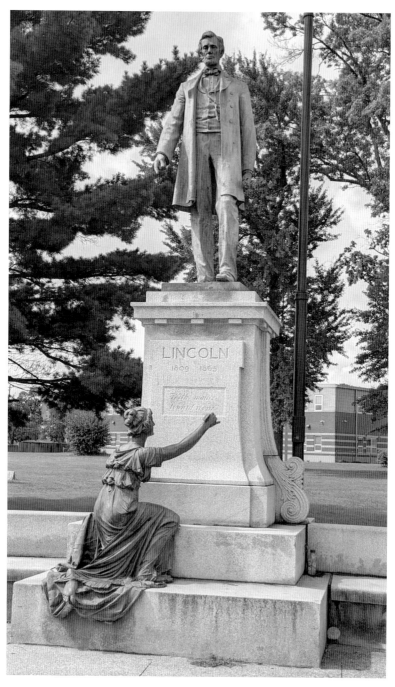

Lincoln monument, Avondale. *Robert Schrage.*

Stadium. Vice President Ford also threw out a first pitch at Riverfront on April 5, 1974, four months before he assumed the presidency. Vice President George H.W. Bush threw out the first pitch at the 1988 All-Star Game at Riverfront. His son George W. Bush did the same thing on April 3, 2006, at Great American Ballpark, thus opening the baseball season. Nearby, President George W. Bush signed the "No Child Left Behind" Bill on January 8, 2002, at Hamilton High School. Candidate and President Bill Clinton visited Cincinnati many times, including for a visit to Washington Park as a former president campaigning for presidential candidate Hillary Clinton in

James Garfield statue, Piatt Park. *Robert Schrage.*

2016. Presidents Donald Trump and Joe Biden, of course, have spoken in the Queen City.

There are other older sites worthy of visiting, including the Lincoln statue in Lytle Park, which was unveiled in 1917. President Taft spoke at the dedication of this statue. A James Garfield statue stands at the Vine Street entrance of Piatt Park downtown. It is one of this author's favorite statues. Garfield was felled by an assassin in 1881, and the concept of this statue was immediately conceived as a tribute to the fallen president. In Avondale, at Reading Road and Rockdale Avenue, there is a Lincoln monument that was unveiled in 1902. Lincoln stands on a pedestal with Lady Liberty keeling before him, writing "and malice toward none."

Worthy of mention but not in Cincinnati is the Ulysses S. Grant birthplace in Point Pleasant, Ohio, about twenty-five miles from Cincinnati. Grant was born there in 1822. In Georgetown, Ohio, his boyhood home and schoolhouse still stand.

NOTES

Chapter 1

1. Suess, *Now and Then*, 7.
2. Ibid.
3. Casey Weldon, "Cincinnati, Ohio River Had Major Roles in Underground Railroad," *Spectrum News*, February 2022.
4. *Cincinnati: A Guide to the Queen City and Its Neighbors*, American Guided Series, (Cincinnati, OH: Wiesen-Hart Press, 1943), 54.
5. Hurley, *Cincinnati: The Queen City*, 31.
6. Cincinnati: A City of Immigrants, http://www.cincinnati-cityofimmigrants.com/.
7. Oppenheimer, *Rivertown Hometown*, 15.
8. Ibid.
9. Ibid.

Chapter 2

10. John G. and Phyllis W. Smale Riverfront Park, www.mysmaleriverfrontpark.org.
11. Peter H. Clark, *Black Brigade of Cincinnati: Being a Report of Its Labors and a Muster-Roll of Its Members etc.* (Cincinnati, OH: Joseph B. Boyd, 1864), 15; "Glory Sought for the Black Brigade," *Journal News*, August 1, 2005, 5.

12. Wikipedia, "Sawyer Point and Yeatman's Cove," www.wikipedia.org.

13. Wikipedia, "Ted Berry," www.wikipedia.org.

Chapter 3

14. Cincinnati History, "Samuel Hannaford: The Man Who Built Cincinnati," December 3, 2019, www.cincinnatihistory.org.

15. Ibid.

16. Suess, *Now and Then*, 98.

17. Wikipedia, "Cincinnati City Hall," www.wikipedia.org.

18. Suess, *Now and Then*, 83.

19. Shelby County Historical Society, "Miami and Erie Canal," http://www.shelbycountyhistory.org/schs/archives/canalarchives/index.htm.

20. Suess, *Now and Then*, 70.

21. Ohio Historical Society, "Church, John, Company Building," 2007, http://nr.ohpo.org/Details.aspx?refnum=94000592.

22. Wikipedia, "Eden Park Station No. 7," www.wikipedia.org.

23. Cincinnati Observatory, www.cincinnatiobservatory.org.

24. Stephen C. Gordon and Elisabeth H. Tuttle, "National Register of Historic Places Inventory/Nomination: Samuel Hannaford & Sons Thematic Resources," National Park Service, August 2, 1978, https://npgallery.nps.gov/NRHP/GetAsset/NRHP/64000626_text.

25. Lorrie K. Owen, ed., *Dictionary of Ohio Historic Places*, vol. 1. (St. Clair Shores, MI: Somerset, 1999), 600–1.

Chapter 4

26. Suess, *Now and Then*, 127.

27. Sue Ann Painter, *Architecture in Cincinnati: An Illustrated History of Designing and Building an American City* (Athens: Ohio University Press, 2007), 152–53.

28. Rolfes and Jones, *Historic Downtown*, 85.

29. "Tour 4," in *Cincinnati: A Guide*, 174.

30. Waymarking, "Dixie Terminal Building," April 27, 2008, https://www.waymarking.com/waymarks/WM3P3Y_DIXIE_TERMINAL_BUILDING_Cincinnati_Ohio.

31. Rolfes and Jones, *Historic Downtown*, 83.

32. Ibid., 23.
33. Janelle Gelfand, "Diana's Tiara Inspires Tower," *Cincinnati Enquirer*, December 26, 2007.
34. Wikipedia, "American Art Pottery," www.wikipedia.org.
35. The Baldwin, www.thebaldwin.com.
36. Wikipedia, "Cathedral Basilica of St. Peters in Chains," www.wikipedia.org.
37. Ibid.
38. Pender, *Oldest Cincinnati*, 72.
39. Saint Francis Seraph Parish, www.sfsparish.org.
40. Ibid.
41. Wikipedia, "Covenant First Presbyterian Church," www.wikipedia.org.

Chapter 5

42. *Cincinnati: A Guide*, 209.
43. Wikipedia, "Over the Rhine," www.wikipedia.org.
44. Tolzmann, *Tour Guide*, 5.
45. OTR Brewery District, "History of Brewing District," www.otrbrewerydistrict. org.
46. Cincy.com, "Over-the-Rhine," www.cincy.com.
47. Cincinnati-Transit.net, www.cincinnati-transit.net.
48. Wikipedia, "History of Over-The-Rhine, Quoting Several Sources Including Miller and Tucker, 3CDC, and the Federal Reserve Bank of Cleveland," www.wikipedia.org.
49. Wikipedia, "Over the Rhine," www.wikipedia.org.
50. Ibid.

Chapter 6

51. *Cincinnati: A Guide*, 179.
52. Wikipedia, "Tyler Davidson Fountain," www.wikipedia.org.
53. Wikipedia, "Cincinnati Municipal Lunken Airport," www.wikipedia.org.
54. Ibid.
55. Tamara York, "Eden Park Hike," *Cincinnati CityBeat*, August 24, 2009.
56. History in Your Own Backyard, www.historyinyourownbackyard.com.
57. "Connors Says Mrs. Remus Tried to Draw Pistol," *Cincinnati Post*, December 3, 1927, 9.

58. Jeff Morris, *Haunted Cincinnati and Southwest Ohio* (Charleston, SC: Arcadia Publishing, 2009), 68.

59. *Cincinnati: A Guide*, 348.

60. Ibid.

61. University of Cincinnati, www.uc.edu.

62. Wikipedia, "Betts House," www.wikipedia.org.

63. Ibid.

64. Wikipedia, "Betts House."

65. Cincinnati Art Museum, www.cincinnatiartmuseum.org.

66. Ibid.

67. Contemporary Arts Center, www.contemporaryartscenter.org.

68. Ibid.

69. Delhi Historical Society, www.delhihistoricalsociety.org.

70. Laurel Court, www.laurelcourt.com.

Chapter 7

71. Sidney Maxwell, *The Suburbs of Cincinnati* (Cincinnati, OH: Geo. E. Stevens & Co., 1870), 2.

72. Ibid., 3.

73. John W. Harshaw Sr., *Cincinnati's West End* (Cincinnati, OH: CreativeSpace Independent Publishing Platform, 2011), 2009.

74. City of Cincinnati, "Thornton Triangle," www.cincinnati-oh.gov.

75. CincyFlags, www.cincyflags.com.

Chapter 8

76. Joseph L. Reichler, ed., *The Baseball Encyclopedia* (New York: MacMillian Publishing Company, 1988), 13.

77. Ibid., 14.

78. Ibid.

79. Wikipedia, "Cincinnati Reds (NFL)," www.wikipedia.org.

80. Wikipedia, "Sports in Cincinnati," www.wikipedia.org.

81. Wikipedia, "Cincinnati Mohawks," www.wikipedia.org.

82. Wikipedia, "Cincinnati Stingers," www.wikipedia.org.

Chapter 9

83. Heather Rockwood, "John Adams's Snowy, Rainy, and Illness-Filled Journey to the Cincinnati Observatory," *Beehive*, August 22, 2022.

84. Northern Kentucky Views, "Hoover," www.nkyviews.com.

85. Ibid.

86. Touring Ohio: The Heart of America, "William Henry Harrison," www.touringohio.com.

87. Ohio History Connection, "William Henry Harrison Tomb," www.ohiohistory.org.

88. Wikipedia, "Carolyn Harrison," www.wikipedia.org.

89. Wikipedia, "Equestrian Statue of William Henry Harrison," www.wikipedia.org.

90. Hans L. Trefousse, *Rutherford B. Hayes* (New York: Times Books, 2002), 8.

91. Wikipedia, "Cincinnati Music Hall," www.wikipedia.org.

92. Paul A. Tenkotte, "Our Rich History: Abe Lincoln Visited This Area Several Times, Named Salmon P. Chase Chief Justice," *Northern Kentucky Tribune*, October 19, 2015.

93. Widmer, *Lincoln on the Verge*, 152.

94. Ibid.

95. Tenkotte, "Our Rich History."

96. Widmer, *Lincoln on the Verge*, 152.

97. Tenkotte, "Our Rich History."

98. Widmer, *Lincoln on the Verge*, 164.

99. Ibid., 164–65.

100. National Park Service, "Cincinnati, Ohio—Inaugural Journey," www.nps.gov.

101. Robert Herron, "How Lincoln Died in Cincinnati," Cincinnati History Museum, www.cincymuseum.org.

102. Ibid.

103. Norman Gasbarro, "Laura Keene and the Bloody Dress—In Cincinnati," *Civil War Blog*, March 17, 2012, https://civilwar.gratzpa.org/2012/03/laura-keene-and-the-bloody-dress-in-cincinnati/.

104. Wikipedia, "Taft Museum of Art," www.wikipedia.org.

SELECTED BIBLIOGRAPHY

WEBSITES

The websites of all the places visited in this guidebook were very beneficial and excellent resources. This author highly recommends visiting these locations' websites for information about hours, closings and special exhibitions. Also, these websites were accessed during the writing of this guide. Updates to these websites are ongoing, and any quotes, notes or references are subject to updates by the appropriate organizations.

BOOKS

Beckman, Wendy. *8 Wonders of Cincinnati*. Charleston, SC: The History Press, 2017.

Boomhower, Ray. *Mr. President: A Life of Benjamin Harrison*. Indianapolis: Indiana Historical Society Press, 2018.

Bortz, Neil, and J. Miles Wolf. *Mount Adams: An Urban Island*. Cincinnati, OH: J. Miles Wolf Photography, 2012.

Campbell, Polly. *Cincinnati Food: A History of Queen City Cuisine*. Charleston, SC: The History Press, 2007.

DuSablon, Mary Anna. *Walking the Steps of Cincinnati*. Athens: Ohio University Press, 2014.

Encyclopedia of Northern Kentucky. Lexington: University Press of Kentucky, 2009.

Feck, Luke. *Yesterday's Cincinnati*. Cincinnati, OH: Writer's Digest Books, 1975.

Goodwin, Doris Kearns. *Team of Rivals*. New York: Simon & Shuster, 2005.

Hurley, Daniel. *Cincinnati: The Queen City, 225th Anniversary Edition*. Updated by Paul Tenkotte. San Antonio, TX: HPN Books, 2014.

Miller, Zane, and Henry Shapiro. *Clifton: Neighborhood and Community in an Urban Setting, A Brief History*. Lynchburg, OH: Commonwealth Book Company, 1976.

Morgan, Michael. *Over the Rhine: When Beer Was King*. Charleston, SC: The History Press, 2010.

Ohio Writers Project. *Cincinnati: A Guide to the Queen City and Its Neighborhoods*. Cincinnati, OH: Wiesen-Hart Press, 1943.

Oppenheimer, Rex. *River Town Hometown: A Celebration of Cincinnati*. Charlotte, NC: Imprint Publications, 2004.

Pender, Rick. *Oldest Cincinnati*. St. Louis, MO: Reedy Press, 2021.

———. *100 Things to do in Cincinnati Before You Die*. St. Louis, MO: Reedy Press, 2016.

Rolfes, Steven. *Cincinnati Landmarks*. Charleston, SC: Arcadia Publishing, 2012.

Rolfes, Steven, and Kent Jones. *Historic Downtown Cincinnati*. Charleston, SC: Arcadia Publishing, 2011.

Steiner, Jim. *Mount Adams: A History*. Cincinnati, OH: Mount Adams Publishing, 2020.

Suess, Jeff. *Cincinnati: Now and Then*. London: Pavilion Books, 2018.

———. *Lost Cincinnati*. Charleston, SC: The History Press, 2015.

Tolzmann, Don. *Over-the-Rhine Tour Guide*. Milford, OH: Little Miami Publishing Company, 2011.

Weeks, Philip, ed. *Buckeye Presidents*. Kent, OH: Kent State University Press, 2003.

Widmer, Ted. *Lincoln on the Verge: Thirteen Days to Washington*. New York: Simon & Shuster, 2020.

Wimberg, Robert. *Cincinnati: Over the Rhine*. Cincinnati: Ohio Book Store, 1987.

INDEX

A

Adams, John Quincy 151, 153
Albee Theater 116
Allison, Doug 142
Alms and Doepke building 48, 49
Alms, William H. 48
American Sign Museum 122
Anderson, Edwin 43
Anderson Ferry 110, 129
Andrew J. Brady Music Center 28
Apostolic Bethlehem Temple
 Church 88
Armstrong, Neil 108
Arnold's Bar and Grill 111
Arthur, Chester A. 162
ArtWorks 44, 108, 162
Audubon, John James 122

B

Baldwin Piano 79

BB Riverboats 23
Beck, Walter 48
Berry, Theodore 41
Betts House 124
Betty Blake 23
Bicentennial Commons 19, 34, 39,
 40, 41
Biden, Joseph 175
Black Brigade 34, 39, 136
Black Music Walk of Fame 28
Blaine, James G. 162
Booth, Junius Brutus, Jr. 167
Booth, Junius Brutus, Sr. 168
Brainard, Asa 142
Bremen Street 96
Brighton German Bank 94
Brown, Paul 148
Burnet house 157, 165, 166, 167
Burton Hazen 21
Bush, George H.W. 175
Bush, George W. 173, 175

C

Captain Stone House 61
Carew, Joseph T. 67
Carew Tower 65
Carol Ann's Carousel 34
Carter, Jimmy 173
Cathedral Basilica of Saint Peters in
 Chains 83
Chabot, Steve 38
Chandler, A.B. 67
Charles, Ezzard 82, 108, 118
Chief Bold Face 129
Christ Church Cathedral 84
Christian Moerlein Brewing
 Company 96
Churchill, Winston 12
Cincinnatian Hotel 11, 50, 173
Cincinnati Art Academy 101
Cincinnati Art Museum 107, 125
Cincinnati Bell Company Building
 82
Cincinnati Bengals 147, 148
Cincinnati Center City
 Development Corp. 100
Cincinnati Children's Museum 121
Cincinnati City Hall 47
Cincinnati Fire Museum 122
Cincinnati History Museum 121
Cincinnati Museum Center 9,
 121, 173
Cincinnati Observatory 56, 141, 152
Cincinnati Reds 31, 76, 125, 142,
 143, 145, 146, 147, 148, 150
Cincinnati Reds Hall of Fame and
 Museum 150
Cincinnati Red Stockings 142, 143,
 145, 146
Cincinnati Royals 149

Cincinnati Stingers 150
Cincinnati Stock Exchange 53, 68
Cincinnati Streetcar 46, 101
Cincinnati Type and Print
 Museum 130
Cincinnati Water Works 40, 50
Cincinnati Zoo and Botanical
 Garden 118
Cincinnatus 17
Civil War 21, 23, 24, 32, 34, 61,
 101, 126, 136, 157, 159,
 166, 169
Clinton, Bill 175
Clinton, Hillary 175
Coney Island 36, 109
Contemporary Arts Center 125, 126
Cook, Cheryl 120
Cooke, Ed B. 11
Covenant-First Presbyterian
 Church 88
Cox, George "Boss" 58, 61, 81,
 82, 118
Crane, Charles Howard 49
Crosley, Powell 76
Crosley Square 74

D

Davidson, Tyler 58, 105, 107, 118
Delhi Historical Society Farmhouse
 Museum 129
Delta Queen 38
Denman, Mathias 15
Dennison, William, Jr. 164
Dixie Terminal 53, 68
Doepke, William F. 48
Doolittle, Jimmy 110
Doytt, John 169
Drake, Daniel 120, 122

Duncanson, Robert S. 126
Duveneck, Frank 48

E

Eden Park 50, 54, 55, 61, 79, 112,
 114, 116, 120, 125, 153
Eisenhower, Dwight 173
Eldridge, Louisa 169, 170
Elsinore Arch 50
Emery, Thomas 32, 50, 67
English, William H. 162
Ensemble Theatre 101

F

FC Cincinnati 148
Filson, John 15
Findlay Market 7, 12, 96, 101, 147
Ford, Gerald 172
Fort Washington 16, 20, 71
Foster, Stephen 71, 72
Fountain Square 105, 107

G

Garfield, James 162, 175
German National Bank 68
Giles, Warren 67
Gould, Charlie 142
Grant, Ulysses 46, 157, 175
Great American Ballpark 38, 125,
 143, 145, 146, 150, 175
Great American Tower 71
Greater Cincinnati Police
 Museum 123
Guilford School building 16, 71
Gwynne building 80

H

Hadid, Zaha 126
Hancock, Winfield S. 162
Hannaford, Charles B. 52
Hannaford, Samuel 12, 42, 43, 44,
 45, 47, 48, 49, 50, 53, 54, 55,
 56, 58, 61, 62, 64, 118, 153
Harding, George 163
Harrison, Benjamin 155, 157
Harrison, William Henry 13, 84,
 155, 157
Hauck, John 95, 96
Hawk, Harry 169
Hayes, Rutherford B. 13, 159, 162
Hebrew Union College 24, 123
Heckewelder, Pierson 88
Herancourt, George 95
Herndon, William 163
Herzog, E.T. "Bucky" 74
Herzog Studios 74
Heston, Charlton 173
Holocaust and Humanity Center 24
Hoover, Herbert 153, 154
Hope, Bob 173
Hughes, Howard 110
Hurley, Dick 142

I

Immaculata Church 89, 90
Ingalls building 68

J

Jackson Brewery 96
J.G. John and Sons Brewery 96
John Church Company building 53
Johnston, Joseph 157

K

Keene, Laura 168, 169, 170
Kennedy, John F. 165
King Records 74, 141
Kroger 31, 72, 118
Krohn Conservatory 54, 112, 153
Krohn, Irwin M. 112
Kutnitzky, Sigmund 88

L

Lafayette, Marquis de 88
Lambrinides, Nicholas 129
Laurel Court 130
Lee, Robert E. 157
Leonard, Andy 142
Lincoln, Abraham 13, 68, 72, 157,
 162, 163, 164, 165, 166, 167,
 168, 169, 175
Lindbergh, Charles 110
Lloyd Library 124
Longworth, Nicholas 112, 126,
 153, 154, 170
Longworth, Nicholas, III 153, 154
Losantiville 15, 17
Lucas, Jerry 149
Ludlow, Israel 15, 140
Lunken Airport 173
Lunken, Edmund H. 110
Lunken, Eshelby 110

M

Mallory, Mark 38
McKinley, William 157
McLaughlin, James W. 126
McVey, Cal 142
Memorial Hall 46

Mercantile Library 80
Miami and Erie Canal 23, 49, 94,
 96, 98, 162
Mitchel building 56
Mitchell mansion 62
Mitchell, Richard H. 62
Moeller, Henry 92
Moerlein, Christian 95
Moonlite Gardens 109
Mundenk, Carol 88
Music Hall 11, 44, 45, 46, 101,
 104, 125, 162, 173

N

Nast Trinity Church 62
Nast, William 62
Nathan, Syd 74
National Steamboat Monument
 21, 38
National Underground Railroad
 Freedom Center 19, 122
Neff, Peter Rudolph 88
Newport Southbank Bridge
 Company 39
Nippert Stadium 12, 120, 148
Nixon, Richard 173
Norman Chapel 56

O

Obama, Barack 173
Obata, Gyo 71
Old Saint Mary's Church 84
O'Malley's in the Alley 111

P

Palace Hotel 50

Patterson, Robert 15
Paycor Stadium 28, 41, 148
Plum Street Temple 24
Pope John Paul II 83
Porkopolis 19, 40, 94
Probasco Fountain 58
Probasco, Henry 58, 107, 118
Procter & Gamble 28, 70, 71, 80
Proctor, Edwin 44
Purcell, John Baptist 89, 90
Purple People Bridge 39

R

Ranney, Moses 80
Reagan, Ronald 173
Reeves, George 56
Reiss, Winold 121
Remus, George 116
Remus, Imogene 116
Republican Club 76
Republic Street 96
Rettig, John 48
Richardson, H.H. 47
Riverfront Stadium 31, 145, 148, 150, 175
Robertson, Oscar 120, 149
Roebling Suspension Bridge 19, 29, 31, 32, 112
Rogers, James Gamble 130
Rookwood Pottery 76
Roosevelt, Alice 154
Roosevelt, Theodore 154
Rose, Pete 40, 145

S

Saint Francis Seraph Parish 86
Saint Francis Xavier Church 84

Saint George's Catholic Church 62
Saint John's German Protestant Church 88
Saint Lawrence Church 90
Sawyer, Charles 40
Sawyer Point 21, 36, 38, 39, 40, 41
Scott, Caroline Lavinia 155
Scott, John 155
Serpentine Wall 39
Shamir, Titzhak 173
Sherman, William Tecumseh 157
Shillito Department Store 12
Simmons Milling Company 29
Skirball Museum 24, 123
Smale, John Gray 28
Smale Park 34, 36
Spencer, Donald 112
Spencer, Marian 36
Spring Grove Cemetery 44, 45, 56, 62, 72, 76, 95, 116, 170
Stanton, Edwin M. 163
St. Clair, Arthur 17
Steamboat Hall of Fame 38
Steinkamp, Joseph and Bernard 80, 128
Storer, Maria Longworth Nichols 76
Stowe, Harriet Beecher 19, 81, 125
Sultana 39
Sweasy, Charlie 142

T

Taft, Alphonso 170
Taft Theatre and Masonic Center Buildings 68
Taft, William Howard 13, 125, 170, 172
Tall Stacks 39, 40
Terry, William 128

Theodore M. Berry International Friendship Park 41
Thomson, Peter G. 130
Thornton, Eliza 140
Thornton, J. Fitzhugh 140
Tilden, Samuel J. 162
Times-Star building 50
Tinsley, William 43
Truman, Harry 173
Trump, Donlad 175
21C Museum Hotel 125

U

University of Cincinnati 12, 24, 36, 42, 61, 62, 108, 120, 140, 148, 170, 172

W

Walnut Hills United Presbyterian Church 62
Washington Park 45, 94, 101, 104, 120, 175
Waterman, Fred 142
Westin Hotel 116
Wheeler, William A. 162
White Pine Chapel 56
Who, The 38
Wielert, Henry 81, 94, 96
Windisch, Conrad 95
Windisch-Mulhauser Brewing 96
Wise, Isaac 24
Wojtya, Karol 83
Woodward Theater 79
Wright, George 142
Wright, Harry 142

Y

Yeatman, Griffon 39

Z

Zaelein, Joseph 88

ABOUT THE AUTHOR

R obert Schrage is very active in local history circles. He has served on numerous local historical boards and is a frequent speaker on local and regional history topics. In 2015, Schrage received the William Conrad Preservation Excellence Award for Lifetime Achievement for his work in the preservation of local history. His previous works include *The Hidden History of Kentucky Political Scandals*; *Lost Northern Kentucky*; *Legendary Locals of Covington*; *Eyewitness to History: A Personal Journal* (the winner of honorable mentions at the New York, Amsterdam and Florida Book Festivals); and more.